The Muse 2013

"Seasons"

Front Cover Photo by Kaleigh Ross.
Back Cover Photo by Veronica Bontempts.

The Editor of *The Muse 2013* would like to give a special thanks to everyone who made this year's publication of *The Muse* possible. We'd like to give thanks to:

 The Submission Board:

 Carolane Blackford

 Casey Diehl

 Maryse Keyser

 Miranda Muller

 Tiffany Murray

 Alex Reyes

 Tyler Ruth

 Wilhelm Sitz

 Tiffany Murray

 And everyone who submitted to *The Muse*.

Special thanks go out to:

- **Mr. Lovell** - He generously allows us to produce this and without that what would we have? No *Muse*. So thank you so much Mr. Lovell for allowing us to produce *The Muse*.
- **Mrs. Ruth** - For being the benevolent dictator that you are and aiding us in the production of *The Muse*. Even without you, the production of this *Muse* may not be possible.
- **Asa Richerson**- For allowing me to drag you places to help with *Muse* stuff. You helped me hand out notes to students and I am thankful for that.
- **Casey Diehl**- Yes, your thank-you is last, but aren't you supposed to save the best for last? Thank you for all that you've helped me with, from the littlest things like how to format the right sentence to helping me with the final production of *The Muse*. Thing2 forever! :)

And here is one finally thank you for the authors. Just like Mr. Lovell and Mrs. Ruth, if we didn't have the artists submitting their work, there would for sure be NO *Muse*. Thank you so much for all the submissions and we hope you keep submitting for years to come! Long live *The Muse*! :)

-Danielle McCorkle

The Muse 2013 Editor-In-Chief

Table of Contents

Winter..5

"Bucks Ambigram"-Justin Ayers..6

"Locked In"-Veronica Bontempts...7

"The Ultimate Test"-Veronica Bontempts..8

"I Am Order"- Nicholas A. Jennings..9

"The Mirror"-Alex Mahoney..10

"Mountain Highways"-Danielle McCorkle..11

"Sledding"- Danielle McCorkle..12

"You Have To Be You"- Alexandra Reyes...13

Spring..16

"Blue Flower"- Samantha Bixler..17

"A Rose By Any Other Name"- Veronica Bontempts..18

"Koi Pond"- Emily Bradley...19

"Audrey Hepburn"- Morgana Candello...20

"Iris"- Morgana Candello..21

"Focus on The Future"- Samantha Jones...22

"Silent Love"- Alex Mahoney..23

"Arrows"- Wallace McGill..25

"Lost Girl"- Avery Thomas...28

"Love"- Joanna Wolotira..30

Summer..32

"Prey Tell"- Emily Bradley..33

"What Are We Waiting For"- Leanne Goff..34

"Find An Escape"- Kayla Husband..38

"Kingdom"-Maryse Keyser...39

"Barbed Wire"- Danielle McCorkle...77

"License To Drive '54"- Danielle McCorkle...78

"Eternal"- Andy Sherman...79

Fall...81

"The Life of A High School Student"- Veronica Bontempts...82

"The Dream"- Tyler Chandler..83

"Lustfull Slumber"- Alex Mahoney...86

"Why Him"- Alex Mahoney..107

"Pine Cone"- Danielle McCorkle..109

"You'll Understand"- Siobhan Nickerson..110

"Dream Shadows"- Wilhelm Sitz...111

"Him"- Avery Thomas..127

"They Loved"- Avery Thomas..129

WINTER

"That time of year thou mayst in me behold

When yellow leaves, or none, or few, do hang

Upon those boughs which shake against the cold,

Bare ruin'd choirs, where late the sweet birds sang.

In me thou seest the twilight of such day

As after sunset fadeth in the west,

Which by and by black night doth take away,

Death's second self, that seals up all in rest.

In me thou see'st the glowing of such fire

That on the ashes of his youth doth lie,

As the death-bed whereon it must expire

Consumed with that which it was nourish'd by.

This thou perceivest, which makes thy love more strong,

To love that well which thou must leave ere long."

-William Shakespeare

"Bucks Ambigram"

-Justin Ayers

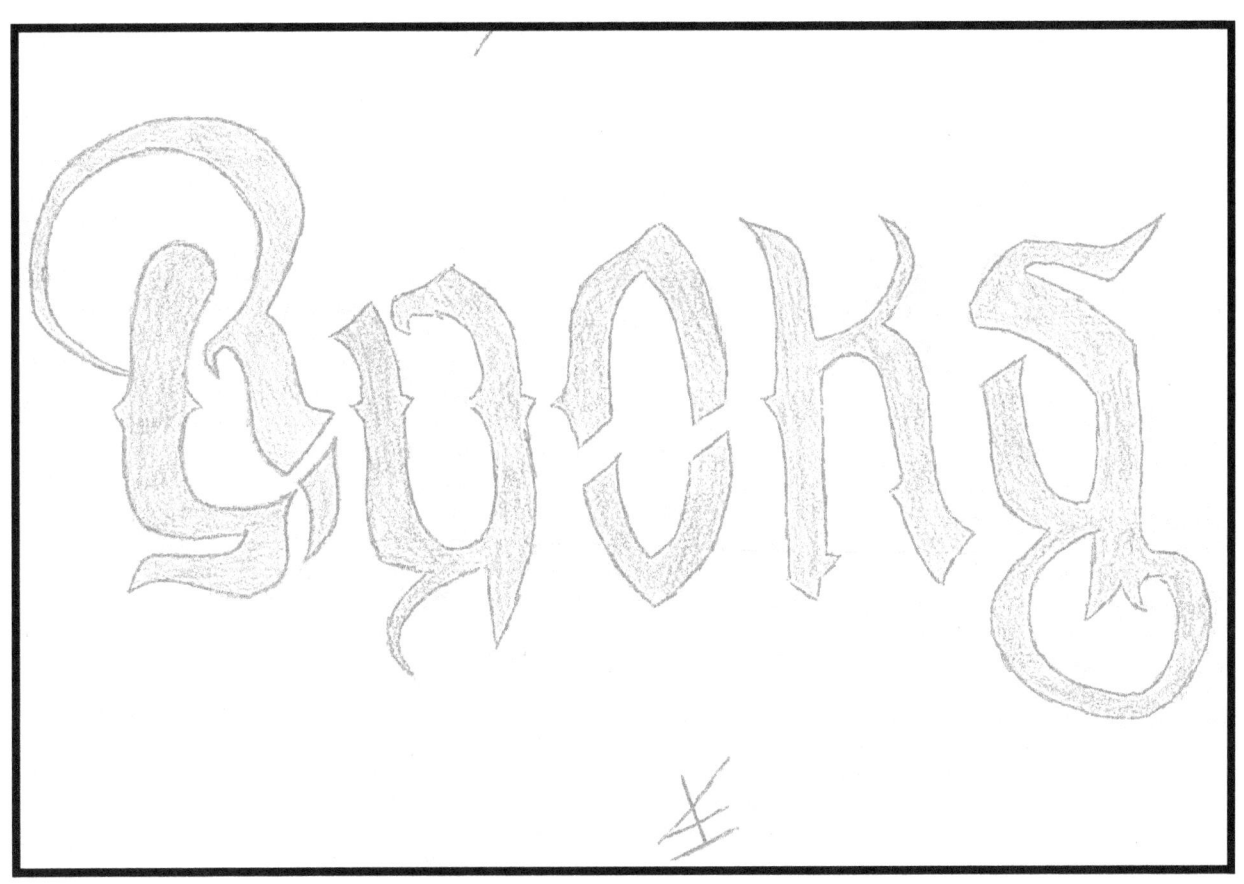

Note: If you flip this piece, you can also find other hidden messages.

"Locked In"

-Veronica Bontempts

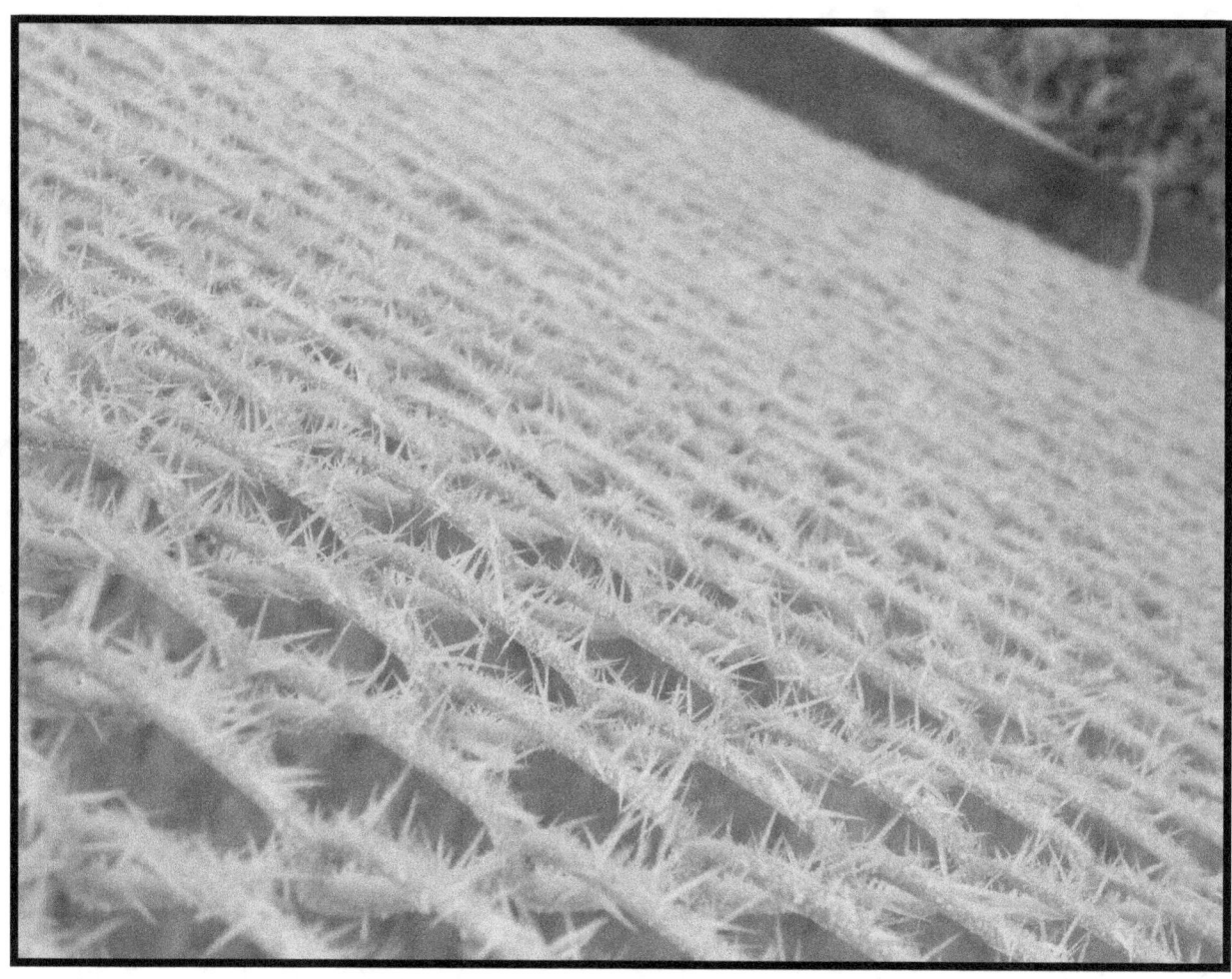

"The Ultimate Test"

-Veronica Bontempts

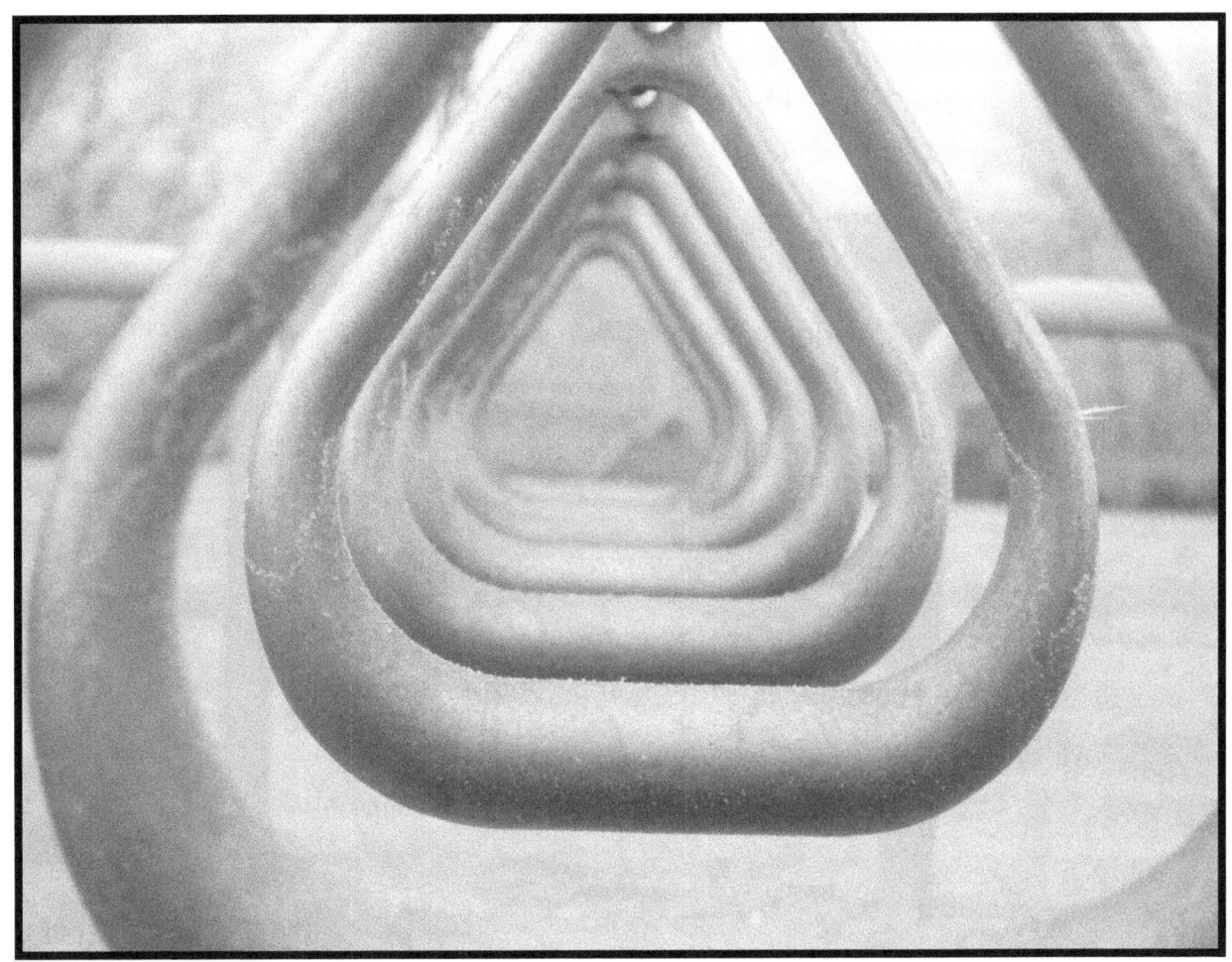

"I Am Order"

-Nicholas A. Jennings

I am Order.

I bring peace to every soul.

I care about your well-being.

I bring chaos to its end,

And bring in a new world and rules.

Leaders and families use me wisely.

But Dictators use me poorly.

In times of darkness, evil shall rise.

But good will triumph and conquer the skies.

And order will bring peace and justice for all.

I am Order.

"The Mirror"

-Alex Mahoney

Can the mirror call me beautiful?

I wish.

Maybe I would cry a little less, maybe I would smile instead of frown.

We have this little game you see, who can make who cry first.

It's an even score of course.

When I look into the mirror, the tears stream down my face,

This face that I want to tear away.

Take off the mask, this, this ugly mask.

It hides all my beauty.

Oh mirror, please mirror, tell me I'm beautiful.

How many times do I have to ask?

Mirror, when can I take off this ugly mask?

"Mountain Highways"

-Danielle McCorkle

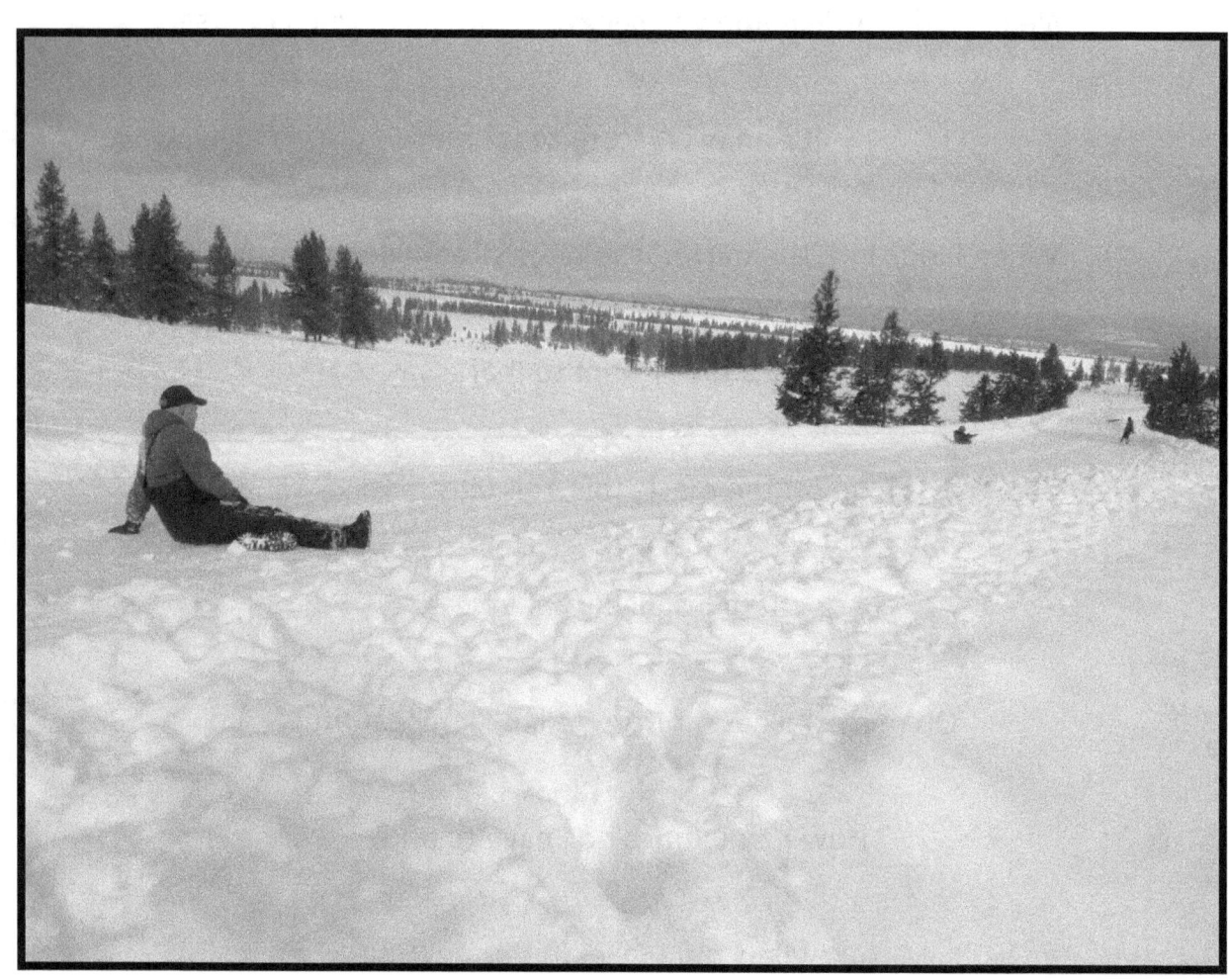

"Sledding"

-Danielle McCorkle

"You Have To Be You"

-Alexandra Reyes

Lost and can't be found

Are you forgotten?

Wonder if you'll find your way

Or stay hiding.

Is it all that difficult to say what you feel?

Can you step out of the darkness and finally heal?

The empty feeling is long overdue;

Feeling like there's nothing left to do.

Time to move on,

Strong is the only option.

Mistakes will happen more than once

But that's part of life.

If you don't do it now, no one will.

At this moment you can't stay still;

You have to be you.

Light shines upon your face;

This is a new feeling.

Not sure if the feeling of existence is wanted.

But it's about time you stand up for what's right;

You have that right.

Time to move on,

Strong is the only option.

Mistakes will happen more than once

But that's part of life.

If you don't do it now, no one will.

At this moment you can't stay still;

You have to be you.

Every night before you go to bed,

Make sure that in your mind

You're ahead of your dream.

Can't look back when you're in the present;

Only look to the future.

Time to move on,

Strong is the only option.

Mistakes will happen more than once

But that's part of life.

If you don't do it now, no one will.

At this moment you can't stay still;

You have to be you,

You have to be you.

SPRING

Sunlight warms my face

And the concrete beneath my feet

Leaves imprints on my soles.

Tufts of grass

Sway flimsily.

A bare tree with the potential

To wear a floral crown

Watches pliant dandelions

Succumb to

A

Swift

Breeze.

-Unknown.

"Blue Flower"

-Samantha Bixler

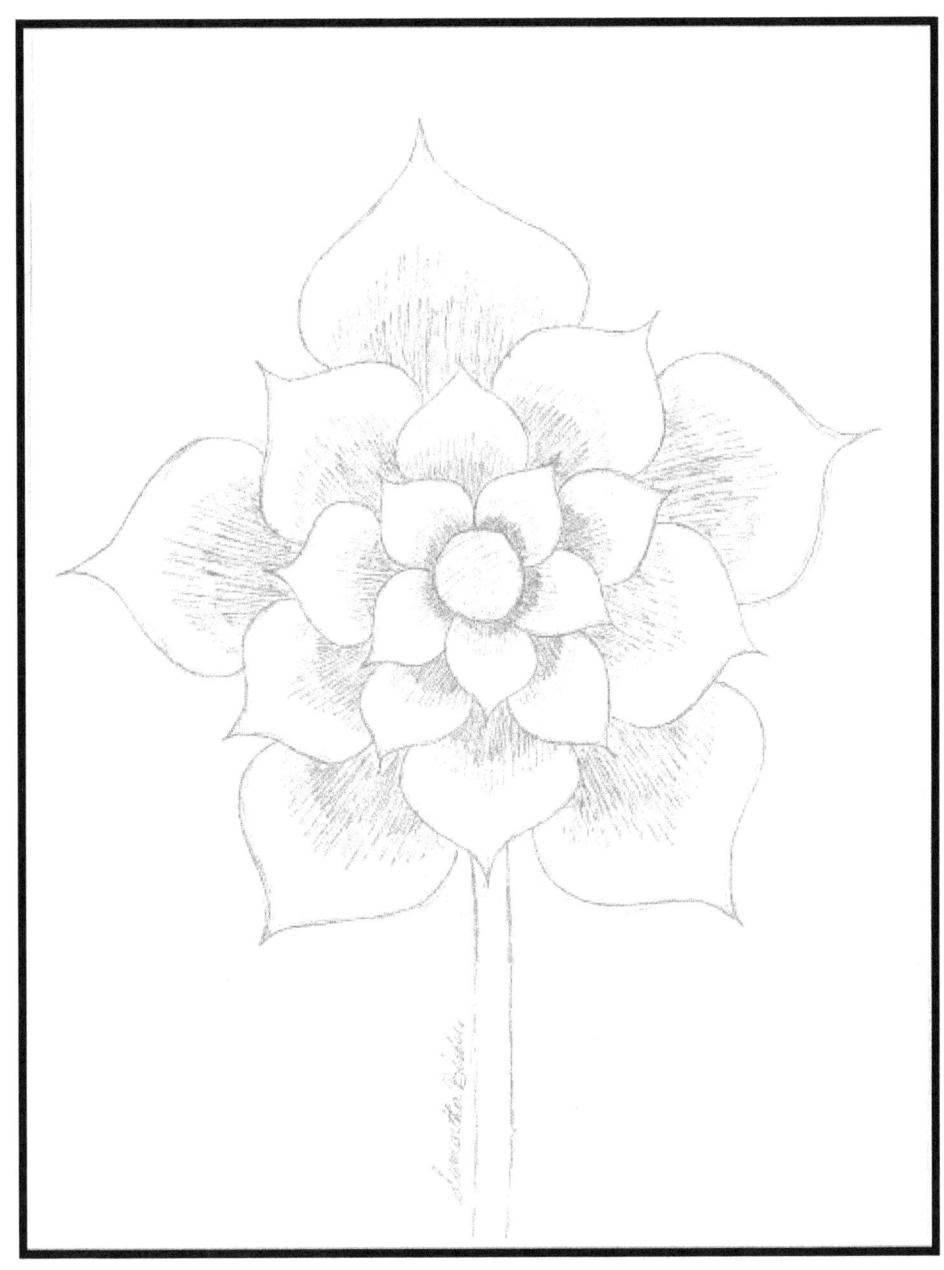

"A Rose By Any Other Name"

-Veronica Bontempts

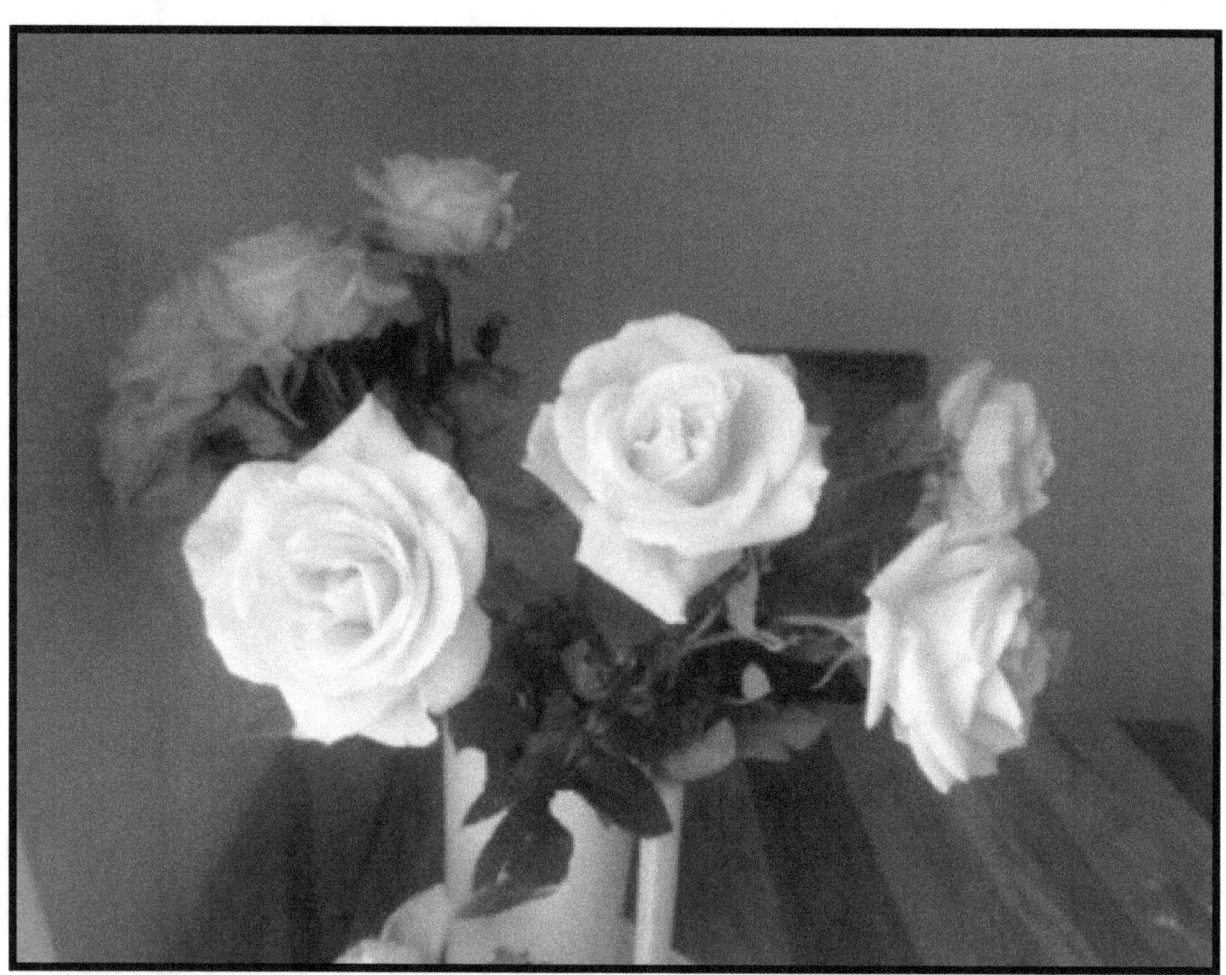

"Koi Pond"

-Emily Bradley

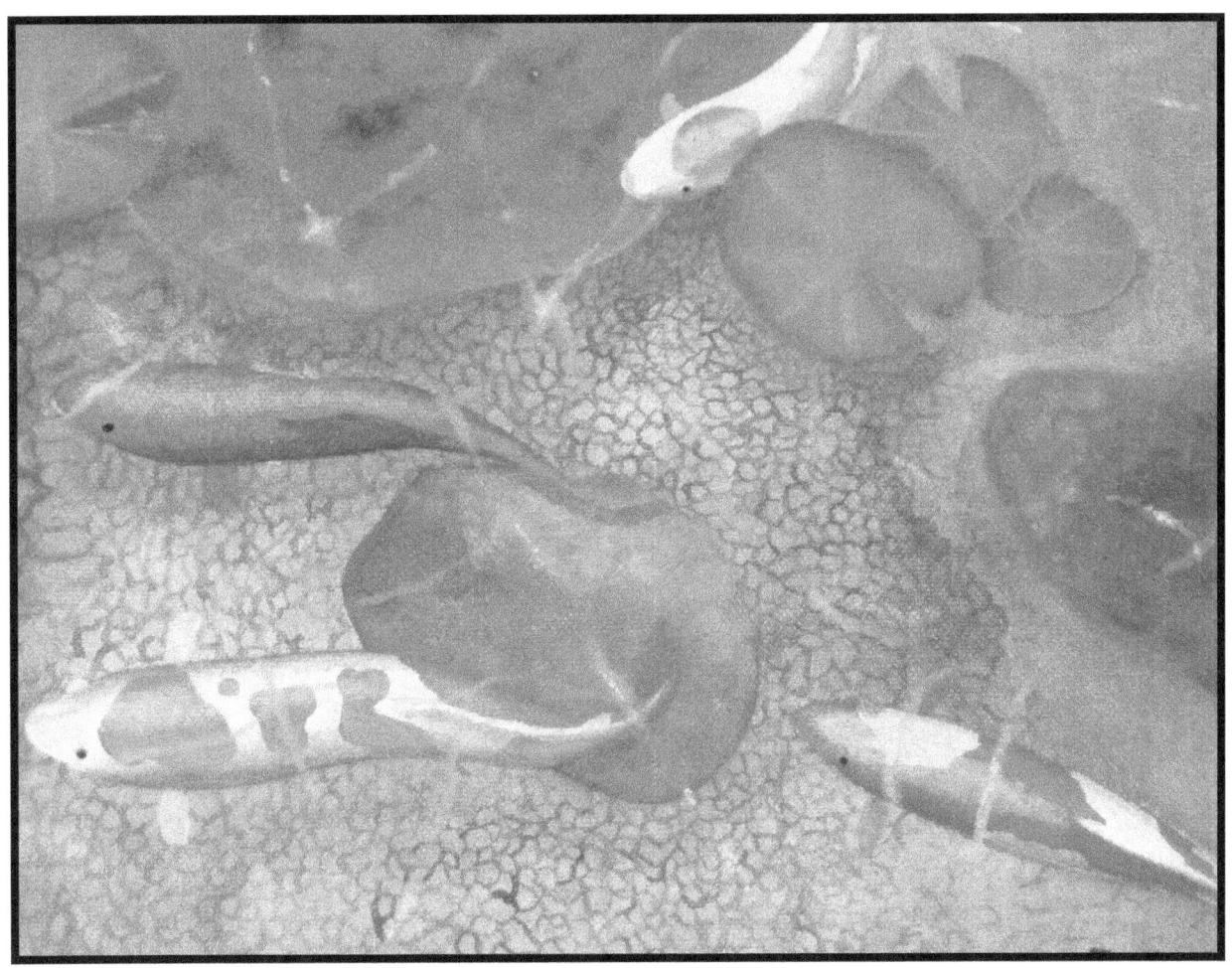

"Audrey Hepburn"

-Morgana Candello

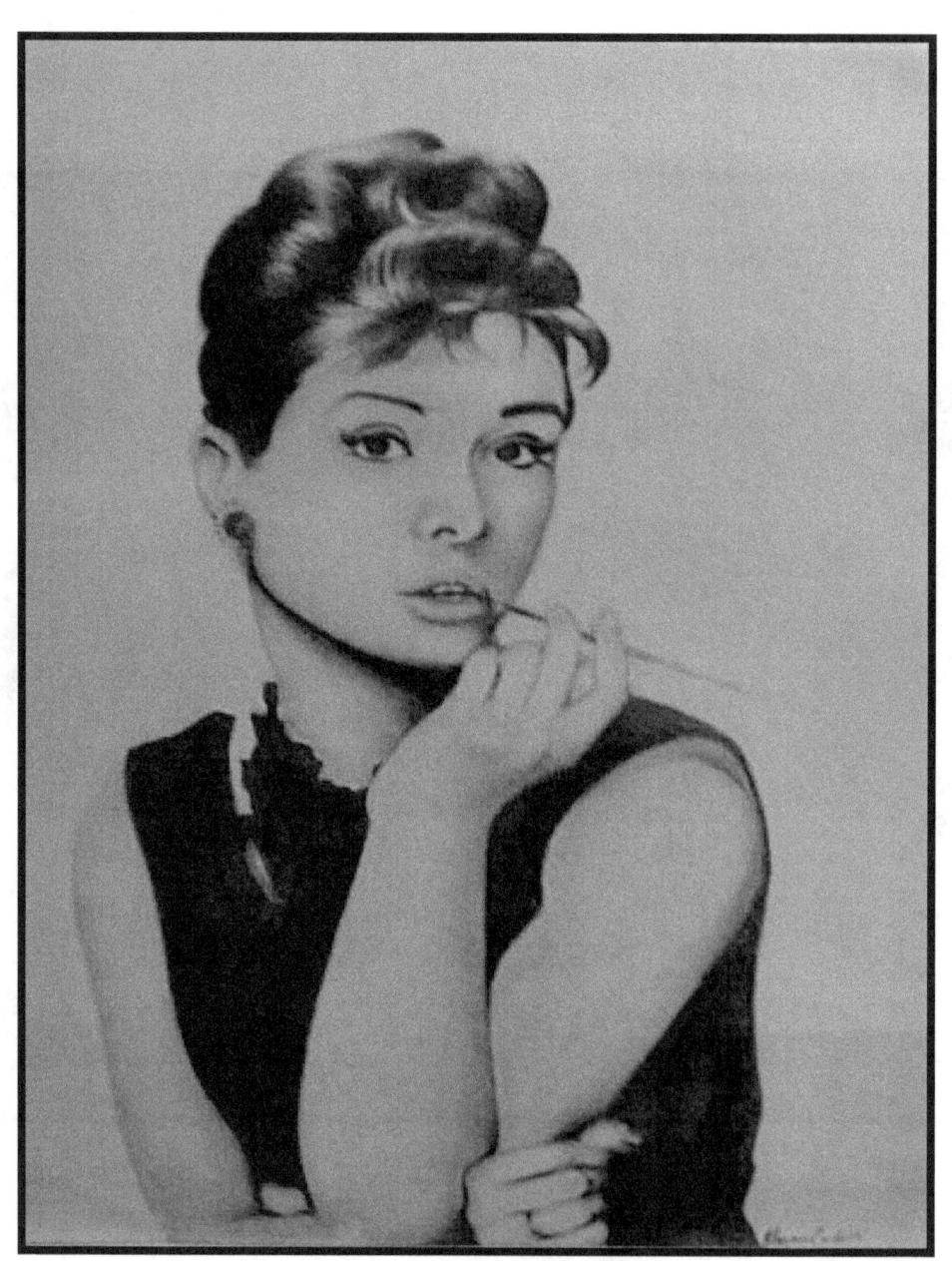

"Iris"

-Morgana Candello

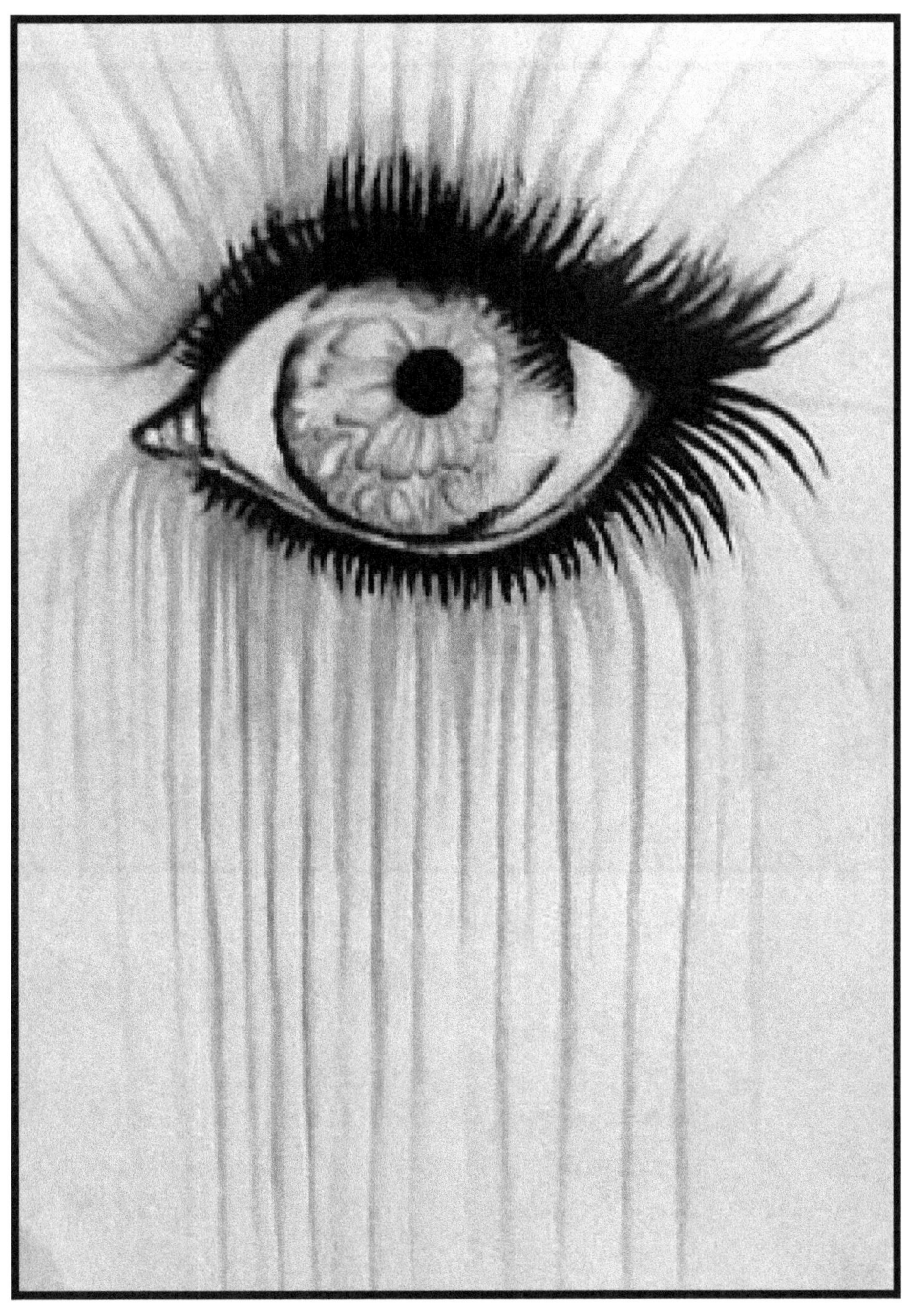

"Focus On the Future"
-Samantha Jones

"Silent Love"
-Alex Mahoney

She sat there, watching him silently, trying not to look noticeable. He sat quietly in her view, nonchalantly flipping his golden hair every so often. Her hands where folded neatly in her lap, while his where limply on the table in front of them. She cocked her head to the side, causing her razor sharp bangs to fall into one of her pale green eyes. He smiled at her, then leaned over and pushed them behind her ear. She stopped his hand, so that it was placed on her cheek.

"You are so sweet." She murmured.

He caressed her cheek with his thumb. Letting go of her cheek he moved closer to her so that they were now side by side. He grabbed her cold hands gently, warming them in his. She wanted this, him. His dark blue eyes looked into hers. They asked questions his lips couldn't. He wondered about her past, and she wanted the answers about his.

Always so quiet before her friends show up. When she saw them, she gave him an apologetic look before putting on her fake smile for everyone. He knew

this to, placing his index and middle finger under her chin; he turned her to face him.

"Don't," He whispered, and then kissed her softly.

"Arrows"
-Wallace McGill

Arrows divide all of time

All of space and thoughts of mine

Flames serene

And deep blue marine

Arrows divide all of time

All of place and thoughts of mine

The hands of time

And heartbeat of mine

Arrows divide my mind

Threw all of time and grind

Across all of the fields

And pastures of green

Yet never yields

Anything greater than green

Arrows divide all of place

All of pain and grace

Never yields and never stops

Never seen and never drops

Arrows divide all of

Space and time

Never lost and never mine

Lost forever on the wings

Of dragons beats

For all of time

Cannot be found threw the winds

Or the valleys and ocean's call

Arrows found and arrows lost

Arrows divide the veil

Between the worlds here

And there

Arrows are the thing of a telling

And are always know but

Never seen

"Lost Girl"

-Avery Thomas

She sits in the quiet, in the dark underground

Her mind on the outskirts, a distant ghost town

A life was once hers, it didn't play out

The demons, the shadows, her heart wants to shout

"Why do you do this?" She hears no reply

Is no one there…….hopes still staked high?

"I do this for torture, for fun, it's for me

It's a game, laugh at your treasure, you see?

What is yours is all mine, you never get past

Your life is an object, a thing doesn't last

Your pain is my pleasure; your wish is a joke

The fun isn't over until one final choke

A corner is distant as far as she knows

Sitting in silence, a withered black rose

The ribbon is torn, the petals askew

Thinking all along, "I wanted you"

With her regret, came sorrowful tears

Still never knowing, who after years…..

The shadows take over, a screech is sent out

The darkness turns darker, a cry full of doubt

"Someone please help me" A whimper of dread

Things that were broken, things left unsaid

She was taken from earth, pulled into her mind

Into her fears, with love, left behind.

"Love"

-Joanna Wolotira

Love is like a rose. Sweet, but sharp as thorns.

Red as the blood spilled from all the battles

That those who have loved will forever mourn.

Love. Looked over, ignored, always trampled,

Cut down, only to grow back once again.

Layered as the feelings for each other,

Which grow and are forgotten now and then.

Feelings often foreign to him or her,

Ever hanging in delicate balance.

So pure, so rare, yet often misleading.

Underestimated in its absence,

Leaving people with broken hearts, bleeding.

Going crazy, in eternal anguish,

But always follows through when it's finished.

SUMMER

Dear friend do not leaveth me

For I truly beg thee to stay,

You bringeth my soul warmth.

Warmth, that not even my loved ones can provide.

Dear friend do not leaveth me

For I truly beg thee to stay.

You bring joy and beauty to the fields,

Joy and beauty that no other thing can possibly provide.

Dear friend do not leaveth me

For I truly beg thee to stay.

Stay by my side, where you belong.

For dear summer, you are truly a friend like no other.

"Prey Tell"

-Emily Bradley

"What Are We Waiting For?"
-Leanne Goff

I look around me

And I wonder why humans think the way they do

I see blonde heads

Brown heads

Red heads

And more

I see brown skin

Tanned skin

Pale skin

And more

Yet humans stubbornly

And foolishly

Continue to think that it's the outside that matter

That the color on skin

Hair

Or religion

Is what dictates a person.

Makes them better or worse than another

Even after we have gone through twelve years of history class

Each class teaching our past mistakes

That humans are based off of the outside appearances

We still foolishly follow the mistakes of the past

Our footprints matching theirs

Instead of learning from our mistakes

Because really, what are brains and reason for?

I see similarity

I don't see higher or lower

I see equality

Two of my best friends chat across from me

Each of their appearances different from mine

Their tanned, dark skin is a stark difference

To my pale, white skin

Their brunette hair

Compared to my red hair

Yet I see them

As an equal to me

I don't view myself higher

Or lower than them

But Equal

I respect their difference in culture

Or religion

Because it does not harm others

But it does not harm others

But it helps humans grow

Humans have got to learn from our mistakes

Or else we will be fighting for our survival

Not form nature

Bur from our own kind

Humans have the potential

To flower

To grow

To mature

So what are we waiting for?

"Find an Escape"
-Kayla Husband

"Kingdom"
-Maryse Keyser

Vast and proud
stands the kingdom,
Reaching over plains
and mountains,
Sea to sea.

Happy and prosperous
the people are,
Love and peace
throughout the land,
Joined hand in hand.

&& I just want to find an escape

Kind and wise reins the king,

Exalted by his people

Respected by his neighbors.

This is where our story lies,

In the kingdom sea to sea,

With the happy people

Who stand hand in hand.

Ruled by the benevolent king

Of this exalted land.

Hard working and low of rank.

Loyalty and courage his only property,

Lies the bright eyed solider.

Up! Up loyal and courageous warrior.

Up onto your feet!

Take your sword in hand

And with your life defend this land,

O' wondrous land!

Beautiful in every way,

Graceful, kind and keen of intellect.

Our king's most precious treasurer,

Sleeps our brilliant princess.

Awaken! Awaken oh beautiful maiden

And dance with your graceful step.

Take in hand you father's kingdom,

Your people's lives

And devote your life to this land,

O' wondrous land!

These are our heroes of our design.

In this kingdom stretching sea to sea.

With the happy people of peace

Linked hand and hand,

Ruled by that exalted king.

Vile, foul of temper, hated by all.

Dark of soul and body,

A sinister look in every gleam.

Be gone! Be gone O' vile being.

That has begun to devise the kingdoms demise.

Take your plans and return to the sand.

Leave our kingdom, leave this land,

O' wondrous land!

Thus plots the evil being,

Within the kingdom sea to sea,

Among the prosperous people

Who turn hand in hand,

Ruled by the respected king.

And so our tale begins,

With a royal ball.

All of the merry people in attendance

To celebrate with their king.

The room decorated in elaborate tastes.

Table adorned with food of angelic delights.

Music begins to play and our princess rises

Grace in every step as our princess turns,

Turns to the music's tide.

Elegance and beauty

Portray each and every move,

The flow of her arms as she twirls to the beat,

The light confident steps of her feet.

The people clap and cheer

To the princess's dance,

The festivities going on into the night.

But our villain does not wait.

With every intention in his evil design,

The dark man attends the party,

With steely eyes he watches her dance.

The key to the kingdom's demise,

Wrought by his own devise.

The end draws near,

In this party of the kingdom's cheer.

With cunning speed the princess is snatched

By the devious fiend.

The people exclaim their fear

The king's soldiers draw their arms

Ready to fight.

Their swords shine with the kingdom's emblem.

Light and pale of metal

Pulls our villain,

Pressed to the princess's neck.

Dark red beads

Give life to the peoples pleas.

Safe passage or the princess's life he cries!

Fearing for her safety

The king calls off his men, not willing to endanger his daughter.

With princess in tow

Our dark man steals away into the night.

Struggling with all her might

The princess fights back,

Kicking and clawing,

Never to be part of this man's plan.

Our hero tending to the horses

Hears her struggles

And watches as the villain carries her away,

Riding off into the night.

Spurred by his heart

The solider takes arm

And mounts his horse.

Swift of foot, dark as night

Gallops the soldier's horse

After the foul man.

Across the land of the kingdom

From sea to sea.

With the people miserable as can be,

Ruled by the heartbroken king.

Over plains and through valleys

Does this story give chase.

O're top of hills and across rivers

Do our combatants run.

Now in this kingdom that reaches sea to sea,

With the miserable people

Who no longer hold hand in hand,

Ruled by the distraught king

Is a land south,

Untouched by the unhappy kingdom.

Comprised of grand rock

And crystallized tears.

Inhabited by the most heart torn of beings.

Beings of little law and many tears.

This is where our riders ride to.

This land of crystal rock.

The ground saturated by tears

And in between

The Kingdom and the Sand

Stands a labyrinth.

A contraption of stone,

Sculpted by unknown hands,

Separates the sorrowful land

And the tearful land.

Into the labyrinth our villain goes

Valiant hero in tow!

The evil man of perfidious deeds

Intending to destroy our hero

Within these rocky walls.

Unfamiliarity at every turn,

Our hero can't discern

The true path to make

That of which the villain did take.

Upon a rocky ledge

Above the warriors head

Sits a trap.

A trap intended to send our hope

Down to the dark world beneath

And rest upon his final bed.

But our princess of great heart

Gives out a mighty call,

And throwing her captor

Warnings erupt from her core.

Away! Away she cries!

With the voice of singing bells

She gives voice,

Away, away!

Do not teary this way!

Into the tunnels and be quick!

Do not stray this way!

Thus come her pleas

Before the O' wretched man

Snatches her away.

Listen! Do you hear?

Do you hear her cries?

O' Courageous hero do you not,

Do you not hear the princess's cries?

The cries that vibrate off of these stony walls

Intended to be your tomb?

Down come the rocks,

The rocks from above.

Down toward his head,

Surely to be his death!

But our hero heeding the princess's calls,

Rushes to the tunnels,

Barely escaping Fate's roll of the die.

Deep, dark, black and full of gloom,

Whispers the tunnels of unfathomable doom.

In plods the warrior,

Searching his way

To taste the light day.

The villain of greet spite,

Who stole the princess,

Did take flight

Across the crystal stone

To his rocky abode.

This man,

This daring man,

Of insidious cunning,

Intends to fit the princess in his plan.

A war machine of incredible power,

Did his mind conjure!

An army of those machines

To take the unhappy people's land.

To by ruled by his own dirty hand.

O' princess

Of the foolish king's pride!

Did that man exclaim.

Build!

Build these machines of my dastardly game.

If you do not

I shall not spare your life,

Your pitiful life!

The princess bows her head,

Agreeing to his demands,

Agreeing to be part of his plans.

O' Treacherous girl!

Would you not think?

But as we have said before

Of this maiden we shall say again!

Graceful, kind and keen of intellect,

Did the princess partake in this deal.

Knowing that the bad man did not understand

His own machines that he would use

To the steal the unhappy people's land.

Diligently she worked,

Tinkering here,

Tinkering there,

Giving the appearance of compliance

Till before her stood a might beast.

A mechanical beast

Of great and terrible power

A monster that towered

And glowered

Upon all of those who stood beneath it.

A terrible invention

That could tear apart the land

And split the sea.

But our princess being of great intellect

Did discern a flaw

Within the evil man's plans.

A flaw that would allow

Her to keep the mighty beast

From crossing beyond the labyrinth.

The villain being none the wiser,

Pleased at her progress,

Ordered more of his mechanical creatures.

So the princess,

Besmeared with grease and dirt

Set upon the task

Of creating these machines again,

Awaiting the solider.

Back in the gloomy, desolate tunnels

Wanders the solider boy,

The exit he did seek.

A glimmer,

A shimmer

Of light dots the gloom.

Hope flutters in his chest

At the light so meek.

Finally, light after the dark week.

Hot oppressive rays

Bear down upon his head,

After bursting from the gloom.

A track of many days

Spread across the sand stained red

To a giant stone,

Stretching to the heavens.

Across the desert he traveled

Thirst clutching at his throat,

His horse's strength unraveled.

Oh how the villain must gloat.

Nearer and nearer

Draws the solider.

Closer to the towering stone,

Closer to the villain's home.

Ten, twenty, a hundred

Beasts glare

Upon our maiden in the villains lair.

Each dyed like the crystallized sand.

Each tinkered by her hand,

Each wrought with that fatal flaw

Bound for the melancholy people's land,

To be brought beneath the villain's law

Happy the villain smiles

Pure mirth upon his face,

To him the machines are a wicked blessing.

Angry the princess frowns,

Full disgust upon her face,

To her the machines are a harbinger of destruction.

The villain laughs and cackles

At the princess's frown

As he locks her away,

But as the door closes

She smiles.

Knowing the beasts won't get far,

She smiles a smile as bright as day.

The smile unseen,

The villain continues to laugh,

Making his way to his grand window.

And what do you suppose he saw?

As he gazed through the glass

Created by the sand

But the solider, trudging up to his front door.

Rage and fury grip the dark man.

Astonishment masks his brow

As he watches the solider

Stumble to the lake and quench his thirst.

A vase shatters in his ire.

How? How did he escape?

He roars, tossing tables and chairs.

He stops and regains his composer.

No matter he muses,

My plan is finished.

He won't live much longer.

I shall crush him myself,

Let him come.

The princess hearing his rage smiles,

Knowing who has caused his distress.

She sets to work,

To escape her prison,

To assist the solider.

A lake as clear as glass

Nestled among the sand.

A reflective surface

That holds the heavens

And brings them to the mortal world,

Creating a door way between the two.

The great stone guarding the entrance.

In this lake the solider gazes,

His eyes, traveling up the reflected stone sentry,

Catch site of the villain.

Their eyes seem to meet

In the mirror world.

The villain grins maliciously.

Our hero gasps

As the surface ripples

And settles,

The man having left the other world.

He rises to his feet,

Knowing the princess is near.

To battle! To battle!

His heart cries among his fear!

The villain,

Having caught the soldier's attention,

Walks to his weaponry

And fastens a mighty weapon to his side.

Meanwhile the princess

Waits and listens to the villain's movements,

Slowly prying the hinges off the door.

Holding her breath,

For fear of being discovered.

The villain marches to his warehouse.

Waking his giant beast,

Whispering orders in gory detail.

Now! Now is the time to act!

Now is the time to test his pet!

Now is the time to take

What he has always wanted!

The solider creeps toward the entrance

In the shadow of the stone guard.

His eyes dart here and there.

On the lookout for danger,

For the princess.

A deep rumbling shakes the ground,

Pebbles dance and skitter over the dirt,

As if they celebrate that most vile contraption,

As a train of evil made metallic rolls forward.

Hearing the beasts mobilizing,

The princess works faster

Lifting the door from its hinges,

Sending it crashing to the floor.

Finally! Freedom!

Free, but not yet safe,

Not yet finished protecting her people.

She dashes down the stairs,

Knowing what must be done,

Hoping it will work.

The monster grumbles,

And growls,

And hisses,

As it rumbles forward.

The villain casually smiles

And waves at our hero,

Like he's rolling out to visit his aunt

Not to bring a kingdom to its knees.

The machine rolls slowly away,

Picking up speed.

Heading for destruction.

Hearing a familiar cry

Our hero turns

And spies our heroin.

Quickly!

We must give chase

Stop him before he reaches the labyrinth!

She sounds, dragging behind her

A machine of incredible speed.

Hurry before it is too late.

Too late to save my father's kingdom,

Our people!

The princess guns the engine.

It revs low with power.

The solider clings to her back

As they dart across the sand

After the hellish contraption.

Clang!

Clamor!

Clangor!

The machine goes,

Crushing and blasting

Everything in its way.

Crossing the desert in hours

When it took the solider days.

The stone maze looms in the distance.

Sand flies in whipping clouds

As they gain ground on the villain.

The solider reaches up

And pulls himself onto the rear car

Then reaches down and lifts the princess up.

The machine of speed

Races ahead and crashes

Exploding into pieces,

Announcing their presence.

The carriage rolls and sways

Beneath their feet

As it speeds toward the stone trap.

They make their way through

The clanking beast.

Heading farther up,

Passing walls lined with weapons,

Shiny swords sheathed in leather

And dull bullets wrapped in copper.

On they go

As the machine chugs beneath them.

Heading for the kingdom stretching sea to sea

With the miserable people

And the disheartened king.

The villain laughs inside the first car

As our heroes enter behind him.

His eye twitches as the door slams shut.

Insufferable brats! He screams,

Drawing his sword.

He lunges at the boy in front of him,

Quick our hero moves to the side luring the villain up and out of the carriage.

Swish

Slash

Swoosh

Hums the sword as it swings at the soldier,

Attempting to sever his life.

I will have my kingdom! the man roars,

Advancing on the warrior trying to hold his ground.

His own sword gleams with the kingdom's light

Its hope

Its life

All hang on his courage.

Below the princess works

Removing wires and disabling weapons

As the train rolls into the labyrinth,

Crunching all in its path.

Her eyes shine with the kingdoms light,

Its hope

Its life

All hang on her intellect.

They dance above,

Weaving in and out

As their swords hiss and click

Trying to devour the life of the other.

Farther and farther down the train they make their way.

The villain traps our hero at the end,

Slicing at his head, shrieking to the skies.

Faster and faster she works,

Exposing the beasts weakness

As it rumbles and grumbles

Over the rocks.

The monster jolts and shudders as our heroin tears at its weakness.

It rattles and shakes

Straining at the ground.

It heaves and it ho's

Losing its balance and power

Losing speed.

As the beast shudders our hero slips and falls before the villain.

The villain's sword strikes against the soldier's skull, downing him.

The soldier's sword slides over the edge,

Lost.

Bringing his arm back for the final blow

The train jolts and throws the man back

As it finally grounds to a stop

The princess's work complete.

No! roars the man

NO!

My pet,

My kingdom,

Lost! all because of a silly girl!

His anger bubbles over and advances upon the princess who has just fought her way free of the control room, joining the duo.

I will destroy you and your kingdom, he raged

Your life I would have spared,

Keeping you for my own.

Now you will suffer the same fate of the boy who lies at my feet.

If you do not breathe life into my contraption

I'll have your head, screamed the man

Seizing her wrist.

The princess refusing to help him any farther kicks out and strikes the man in the knee.

He howls

And yowls

In pain, releasing her.

You brat!

You will pay for that, he said

Slicing at her as she nimbly danced away from his reach.

Rise! Rise O' spirited warrior!

Rise and defend the princess

Gallant hero!

Rise to your feet,

Rise and take courage

Take heart

Defend your kingdom!

Rise, up onto your feet

And protect this land

O' wondrous land!

Stirring, the warrior wakes

And rises to his feet

Courage blooming in his heart.

Fast and strong,

The solider grapples with the mad man.

Struggling for control,

Not for a sword

But for a kingdom from sea to sea

With the people as miserable as can be

And the downtrodden king.

Swift and nimble,

The princess scuffles with the bad man.

Not for a sword

But for a kingdom from sea to sea

With the people as miserable as can be

And the downtrodden king.

Swaying, swinging, and dodging

Our heroes fight.

Swaying, swinging, and dodging

Our villain rages.

With a heave and a ho,

The man of the sand topples

Before our daring duo.

Down.

Down.

Down.

Down.

Over the edge of the beast,

Into a rocky abyss, falls

The dastardly

Man

!

Rejoice!

Our heroes hug and cheer.

Rejoice!

A man

Vile, foul of temper, hated by all.

Dark of soul and body,

A sinister look in every gleam.

No longer!

Gone, gone O' vile being

He who tried to devise the kingdom's demise!

Plans buried in the crystalline sand.

Leave our kingdom, leave from this land,

O' wondrous land!

Hard working and low of rank.

Loyalty and courage his only property,

Stood the bright eyed solider.

Who took sword in hand

And defended this land,

O' wondrous land!

Beautiful in every way,

Graceful, kind and keen of intellect.

Our king's most precious treasurer,

Slept our brilliant princess.

Who took in hand her father's kingdom,

Her people's lives

And devoted her life to this land,

O' wondrous land!

These are our heroes of our design.

In this kingdom stretching sea to sea.

With the happy people of peace

Linked hand and hand,

Ruled by that exalted king.

Once again stands the kingdom, vast and proud

Reaching over plains and mountains

From sea to sea.

Again, happy and prosperous the people are,

Love and peace returned to the land,

Joined hand in hand.

Wise and kind reins the happy king

Exalted by his people,

Respected by his neighbors.

This is where our story ends.

In the kingdom sea to sea,

With the happy people

Who stand hand in hand.

Ruled by the benevolent king

Of this exalted land.

"Barbed Wire"
-Danielle McCorkle

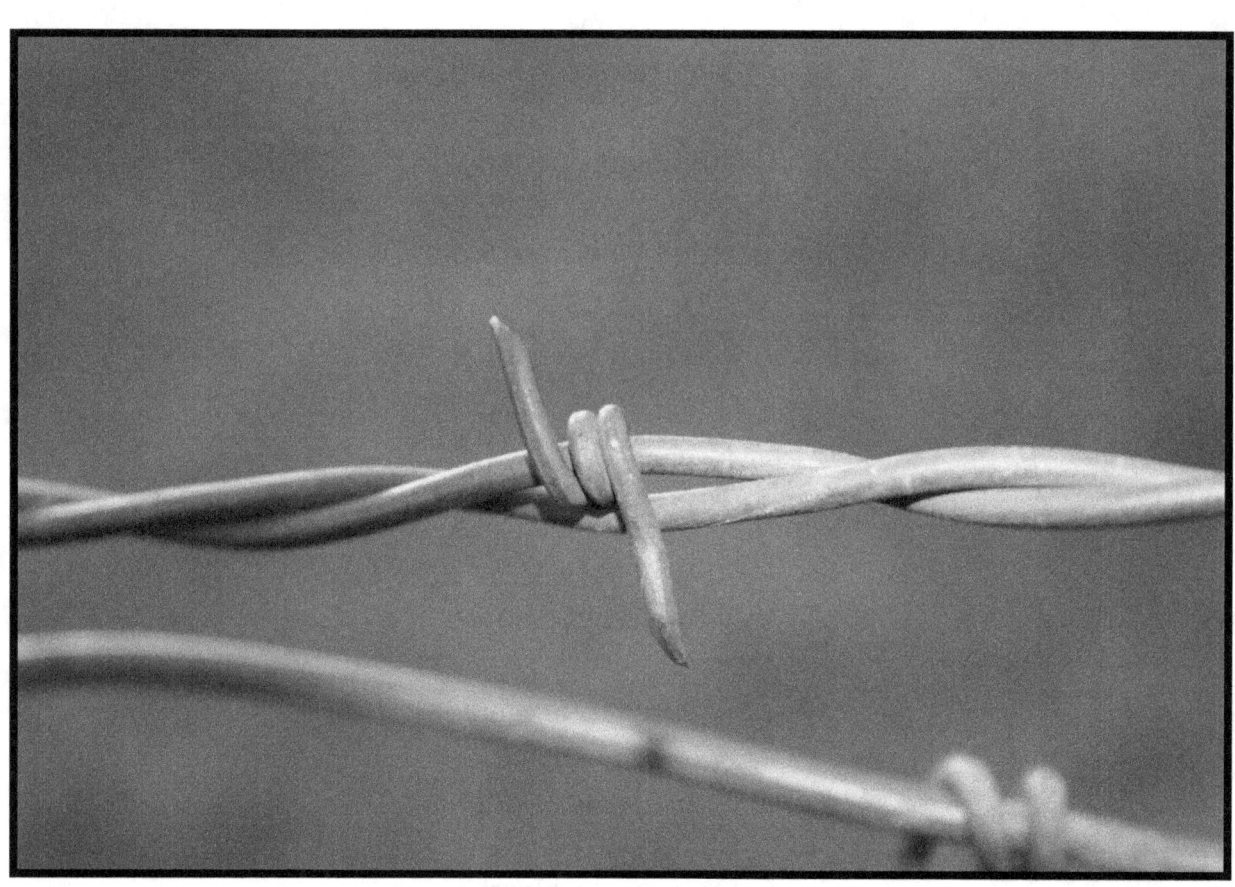

"License to Drive '54"

-Danielle McCorkle

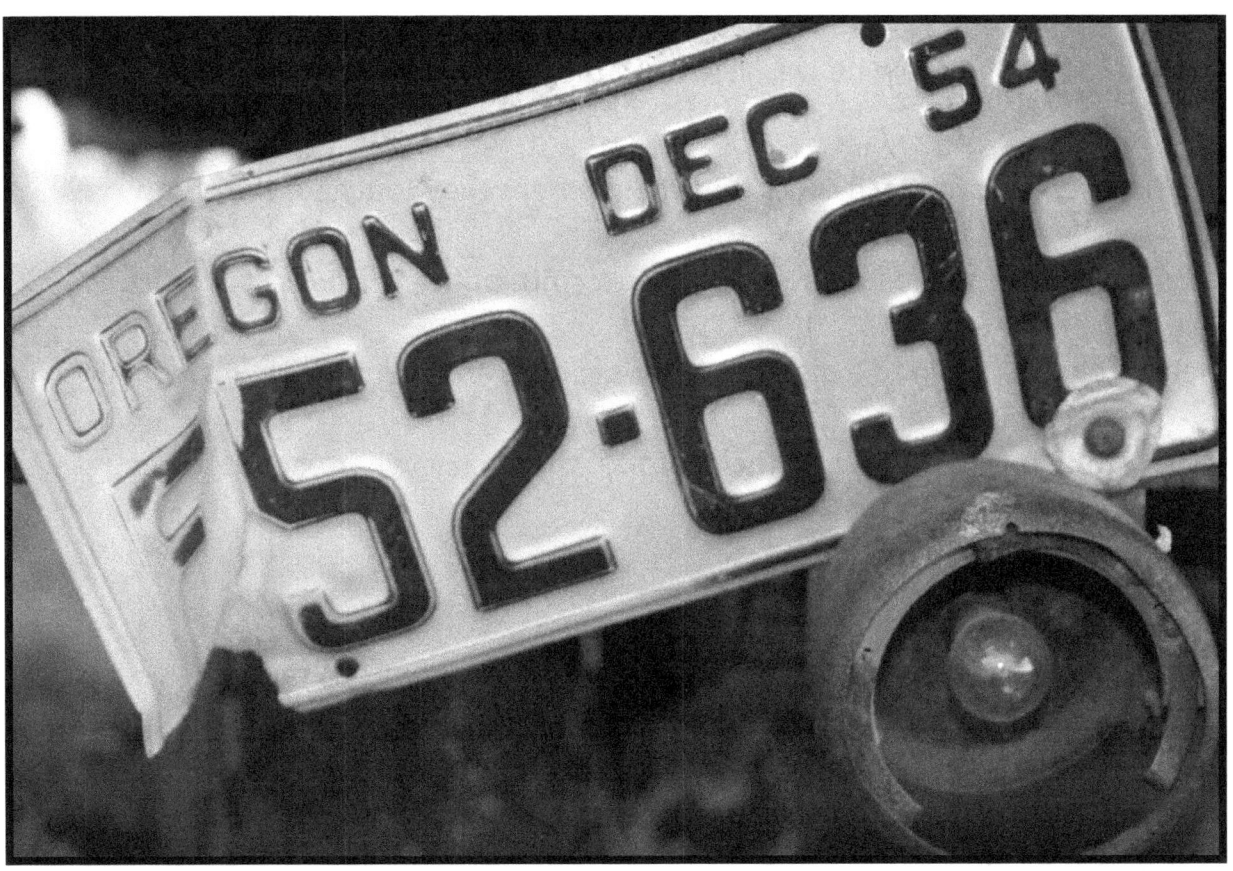

"Eternal"
-Andy Sherman

Their eyes met. The spark they shared was powerful; stars and planets blossomed from the connection, forming a beauteous garden across the universe. In that instant, he knew he was in love with her, and she with him.

They reached for each other, but the moment they touched, they both recoiled in pain. While he possessed the warmth of fire, she was cold as ice. Heartbroken, she ran to a distant corner of space and wept. He, being equally devastated, took a position at the center of the galaxy, where he sat in deep thought.

For many eons, they lamented their misfortune. However, one day, he was struck with an idea. He traveled the universe to find his love. Though she still wept, he led her to a lush planet teeming with the beginnings of life. At first, she was hesitant; but as the tides swirled and bowed around her, she found herself falling in love with the earth.

Once she was content, he executed his plan; with a playful grin, he began chasing her across the hills. At first, she was frightened. But as he followed at a

pace equal to hers, making no move to capture her, she understood his game and ran just as happily. They chased each other through the forests and mountains, over the oceans and seas, never once slowing down. Even as life blossomed beneath their feet, creating magnificent structures with the minerals of the earth, they ran.

Though they could never be together, they were content in their endless race. They were light and dark, day and night, sun and moon as they chased each other across the galaxy.

FALL

As the leaves come falling down.

We see the beauty all on the ground.

The crackle under our feet and make a crunching sound.

Fall is here! I love the season!

The leaves are only one reason!

"The Life of a High School Student"

-Veronica Bontemps

"The Dream"
-Tyler Chandler

I dream of darkness, I dream of pain

The death, the despair, in an endless chain

I feel all the torture as I lay my head to rest

The steel begins to pierce as it slips into my chest

My heart begins bleeding, I fear for the worst

My sanity fading, there's no hope for my soul is cursed

It is the end of me it's all over now

I close my eyes as I feel the sweat drip onto my brow

Thus it begins, the torture restarts

Ripping my soul to pieces and salvaging the parts

I scream out loud but no one can hear

I begin to cry but I can't shed a tear

I open my eye to the creation from which was made up of my soul

The parts gathered, to make this creature black as coal

I stare it in the face but there is nothing to see

For what I am gazing at is the darkest parts of me

I made this shadow, I created this beast

Now it shows me its form and on my heart it begins to feast

I feel its cold wretched claws tearing into my skin

I see a shadow of a man in the corner, a man of darkness, a man of sin

He stops this monster only to speak

He begins to whisper as he rests his cold hand on my cheek

He melts to the floor; the beast is ready to strike

I now wake to reality, to my dream tis nothing alike

The room is dark, the air is cold

I look around but there is nothing for my eyes to behold

I see nothing around me, not a soul in site

Thus I rest my head and absorb the night

I begin to relax, my stomach un-knots

Now I lay to rest and fall back into my thoughts

"Lustful Slumber"

-Alex Mahoney

The air was cold, the night black. He could taste the salt water in his mouth. He gently pulled his sleeve down, more bruises and cuts from his abusive father like always. The wind picked up, as the waves crashed against the cliff's bottom. He looked down as tears fell from his eyes. His feet moved him closer to the edge. Sobbing his last goodbyes, he jumped.

The pain crashed against him. He screamed in agony, but they only mixed in with the thunder. Waves rushed against him, pounding his already beaten body into the sharp rocks. Another wave crashed against him, this time, knocking him out.

His heart beat unsteady according to the heart monitor. His pale body scratched up from head to toe. His mother stood next to the bed, just staring at her son, pleading with God to let him live, to let him see the sun again. His father was sitting in a chair across the room looking bored with it all. The doctor walked in with the results, saying,

"Mr. and Mrs. Dagonal your son is lucky to be alive, the fall scratched him up, but luckily, none of his internal organs were damaged. He's broken some bones, but with time he should have a full recovery."

The boy's Mother smiled tears welling up in her eyes. She thanked the doctor and he left.

Six Months Later

Jason sat on his bed, starring at the black walls he had just painted the week before. A smile crept on his lips. A knock came from his bedroom door.

"Come in." He said standing up.

His mother walked in. She was wearing her work clothes, Black pants, and a elegant blue blouse, she was a therapist who helped psychotic people get on a better track to life. She was a good listener, and always had advice. He stared at his mother, thanking god silently that she had left that horrid man he called a father.

"How are you today?" She asked "You're not very talkative."

"I just haven't been in a talkative mood, but I promise I'm getting better." He said.

She nodded looking at his walls, sighing she walked out.

That night, Jason lay awake. His eyes begged for sleep, but his mind denied it. He thought about the past, like every other night. It seemed like it was haunting him, always nipping at his heels. After hours of looking at the full moon, the sun arose. He rubbed his dark eyes, and then got up from his bed. His long legs brought his body to the bathroom across the hall from his bedroom. He washed his face, and scrubbed his teeth clean. The reflection in the mirror revealed a pale 17 year old boy with shiny brown hair that would make its way into his eyes every so often. His full lips frowned at him, and his almost black eyes held a depth of sadness. Flicking his hair to the side, he dressed in black Levi's and a red V-neck. As he slipped on his black converse, images started to clutter his head. Ones of his abusive father, of his horrid childhood, when he had no friends. Jason gasped and clutched his head, as it throbbed faster than his heart did. Gasping, he searched for his medication, not finding it, as the throbbing sped and the pain increased, he yelled in pain. His eyes popped open when his hand wrapped around the little orange bottle. Popping it open, he slid two dime sized capsules in his mouth and swallowed. They creped down his throat, threatening to stick to his throat until he washed them down with water from the bathroom

sink. Breathing heavily, He sat on the toilet seat and rocked back and forth, telling himself it was okay now, though he knew it wasn't, it was never okay.

Walking to school, he had his favorite song blasting in his ears. The rhythm of the rain patting on his shoulders made him smile. He loved the rain, the way it smelled, and the way it looked, even the way it fell from the dark clouds, and made the soft thump on the concrete. Sighing he made his way into the school's entrance. The huge building stood over three stories, and had a brownish red color. He walked through the double doors making a mental note to himself about studying for a test. As he tried to keep his mind focused in class, he could slowly hear the clock ticking in his head, telling him his time was almost up. Jason squeezed his eyes shut and sighed.

At lunch he sat alone at the only available lunch table he saw. He ate his lunch in silence. This was his daily routine, even though he had a handful of friends, they had their own. He wasn't an outcast; he just wasn't fond of company sometimes. A presence disturbed his thoughts. He looked across from him and saw a girl with straight red hair that had lots of fringe in her bangs; He dark green eyes sparkled at him. Then she spoke.

"Uhm, Hi. My name is Allie, and I'm new. The office said they couldn't get anyone to show my around. And I'm lost."

Jason looked at her and said,

"And you decided to ask the weirdo sitting alone?"

Allie giggled,

"No. I asked the first person I saw but they just scoffed at me and walked away. I've probably asked 25 people so far. You're the first boy."

"That explains it then." He said with a smile.

Her cheeks began to brighten and she shrugged.

"So, is that a yes?"

He nodded, and rose to throw his trash away.

Two Weeks Later

The encounter with Allie had thrown him off, His whole mood, everything. He couldn't stop thinking about her, the way her naturally dark red hair shined in the sun, the way her dark green eyes shined in his. And how her body fit exact

with his when they hugged. He was in his room, when his phone buzzed on the table next to his bed. He slowly smiled, seeing it was from Allie.

Wanna hang out?

He replied with a yes. And they met up at a park nearby his house. She arrived wearing bright blue skinny jeans and a band tee shirt under her sweater.

"Hey," She said hugging him.

He smiled and said, "Hey. So what's up?"

She looked down a moment then back up and he could see her cheeks start to brighten.

"Uhm. Well After class Friday, Shane came up to me and kissed my cheek. Then he asked me to be his girlfriend"

Jason's smile was a complete frown, He looked at the ground a moment before saying,

"Oh, well Shanes' a nice guy,-" She cut him off.

"I didn't say yes."

A surprised look formed on his face.

"Why?"

She smiled and stepped closer to Jason. Grabbing his hand with hers she said,

"Because I like someone else."

Before he could stop himself he said,

"Who?"

She giggled. "You silly!"

Then her face fell, and she let go of his hand.

"It's okay if you don't like me back,-"

Jason's lips cut her off. His arms pulled her closer and he felt her smile. Jason knew this would only last a while, He had never been good with romances, and since he was psychotic, it was hard for girls to like him. He had the looks, just not the emotions sometimes. She pulled away and smiled up at him.

"What was that for?" She asked surprised.

Jason smiled and shrugged.

"I didn't want you thinking that I didn't like you."

She grinned at him. He frowned a bit.

"I think I should tell you about my past a bit before anything else."

She nodded and they sat on the swings. He started off with his childhood, and when his imaginary friends became mean voices in his head that wouldn't shut up, And when they got aggressive each night, his mother and father took him to see a doctor, He told her how they said he was crazy, and how there was no hope for him. He described the feelings his medication gave him, how he was sad all the time, and had no friends because it would make him cry.

"It was like it was controlling me," he said.

Then he told her when his father got violent.

"I remember it like a dream I wanted to wake up from. I was in 6th grade, and it was a bright sunny day. I was in my room, crying because the pills the doctors gave me made my head hurt. My dad came in and told me to shut up and be a man. When I wouldn't he yelled and slapped me, saying 'there's something to cry about.' When I told my mom, she didn't believe me. When I wouldn't take my medication, he would shove them down my throat. Then my doctor gave me pills that didn't make my head hurt, but i still heard the voices, I even saw strange

figures everywhere. When my dad came to tell me dinner was ready one night, I thought he was one of those scary figures, and the voices told me gruesome stories they made up about him, I got up and started hitting him. Yelling at him to go away. My dad picked me up by my arms and threw me against the wall, I hit my head, but he came over to me and just started hitting, putting bruises all over my body." he paused and looked at Allie who was teary eyed.

"Five years. That's how long I got beat before I tried to commit suicide. Jumped off the cliff at the edge of town after my dad beat me pretty bad, and said a lot of hurtful stuff. It's pretty painful, crashing into the rocks. I don't even remember how I got out of them. I woke up in the hospital a week later. Mom told me she left my dad and that we were safe. I haven't seen or heard from him since. Sometimes I get crazy nightmares. They make my head hurt. It's like, having a hammer hit against it, over and over again. I take Medication that stops the voices, and the headaches. I take about five or six pills before school and four before I go to bed. I've gotten used to it, but I do have psychotic break downs here and there."

Jason looked at Allie and saw the tears streaming down her face. He whipped them away with his thumb. She hugged him tightly.

"I'm so sorry!" She sobbed into his neck.

He pulled away and put his hands on her shoulders.

"It's okay." He smiled.

"I'll never be completely cured from it, but I can at least subside the symptoms with my medication."

He smiled at her, she just hugged him again.

The light in the sky began to darken, and Jason walked Allie home. She tightly grasped his hand, as if he would float away at any moment. When they arrived at her house, Jason looked at it. It looked like it had two floors, and was light blue, with a red door and steps. The roof was light grey, and four windows where in the front, all framed with white paint. She looked up and smiled at him. He kissed her forehead.

"I don't want you to leave." She whispered.

"Why?" He said in puzzlement.

She bit her lip and spoke softly looking at the pavement beneath their feet.

"They always fight. My mom and her boyfriend. Always yell. He's never hit me, but what he says." She grimaced.

Jason pulled her to him, and smoothed her hair with his hand. She sighed.

"I'll see you tomorrow." She said pulling away.

He smiled. "Trying to get rid of me?" He raised his eyebrows.

She gave him a small smile.

"I'll stay a while; I just have to talk to my mom."

Allie's smile grew.

"Okay."

Jason called his mom and told her he wouldn't be home till late.

"Are you staying over?" She asked worried.

"No, and don't sound so worried mom. I'll be fine."

"I know, I just. Just call me if you need a ride home." she said.

"I will." Jason said.

"Okay love you bye."

"Love you too, mom. Bye."

He hung up and looked at Allie who was giggling.

"What?" he asked.

"Nothing, your just nice to your mom is all. It's cute."

She grabbed his hand and led him to the front door. Opening it, they walked in. A woman in her late thirties was sitting at a desk typing. She looked up, and her dark green eyes had a questioning look. She smiled.

"Hello Allie, Who's your friend," she asked.

Allie let go of Jason's hand and said,

"Mom this is Jason."

Allie's mom smiled and stood up, walking over to them she put her faded red hair into a bun. Holding out her hand to Jason She said,

"Hello, I'm Christina."

Jason grabbed her thin hand and nodded. Allie smiled and said,

"Is Bryson home?"

Christina shook her head.

"No, he got stuck at the office, won't be for a couple of hours or so."

Allie nodded, and said they were going to her room. When they went up the stairs Jason glanced back and Christina was glaring at him. Allie stopped at a door different from all the others, which were white. This one was pure black. She turned the knob and stepped into the room. He followed. When she turned the light on. The room turned out to be a maroon color. With hand prints on the ceiling, and zebra stripes on one wall, on the other three where just the plain maroon color, with posters of bands. He guessed it was Allie's. She smiled at him.

"Your room is pretty epic." He said smiling. "I'm jealous."

She sat on her bed, which had a blood red comforter, and black pillows, He sat next to her.

"Are we, together?" She said with pauses.

He looked at her and touched her hand.

"I want to be with you. The question is: Do you want to be with me?"

She looked at him and smiled.

"I've never wanted anything more."

He smiled and kissed her lips passionately. They pulled apart at the same time. She plugged her IPod into her speakers and let music fill the room. Jason lay on her bed. Allie laid her head on his chest and listened to his heart while Jason Mraz sang I'm yours. They both ended up falling asleep.

The breeze blew his face as the waves crashed against the rocks below. His feet moved closer and closer to the edge. His heart fluttered in his chest when her voice spoke.

"No! Jason!"

He didn't listen as the tears streamed his face. Arms grabbed him from behind. She hugged him from behind. Begging him to stay with her. His eyes were glued to the water below. The sparkling blue. It whispered his name. And just like that, he was falling again, into an abyss of emptiness. The sharp, jagged rocks below, turned into teeth as they crunched his body to pieces, leaving nothing.

Jason gasped, and sat up, sweat streaming his forehead. The clock on Allie's side table said it was 3a.m. He wiped his forehead. Allie was under the covers beside him, dressed in shorts and a tank top. Even in just his boxers, it felt like a

Christina shook her head.

"No, he got stuck at the office, won't be for a couple of hours or so."

Allie nodded, and said they were going to her room. When they went up the stairs Jason glanced back and Christina was glaring at him. Allie stopped at a door different from all the others, which were white. This one was pure black. She turned the knob and stepped into the room. He followed. When she turned the light on. The room turned out to be a maroon color. With hand prints on the ceiling, and zebra stripes on one wall, on the other three where just the plain maroon color, with posters of bands. He guessed it was Allie's. She smiled at him.

"Your room is pretty epic." He said smiling. "I'm jealous."

She sat on her bed, which had a blood red comforter, and black pillows, He sat next to her.

"Are we, together?" She said with pauses.

He looked at her and touched her hand.

"I want to be with you. The question is: Do you want to be with me?"

She looked at him and smiled.

"I've never wanted anything more."

He smiled and kissed her lips passionately. They pulled apart at the same time. She plugged her IPod into her speakers and let music fill the room. Jason lay on her bed. Allie laid her head on his chest and listened to his heart while Jason Mraz sang I'm yours. They both ended up falling asleep.

The breeze blew his face as the waves crashed against the rocks below. His feet moved closer and closer to the edge. His heart fluttered in his chest when her voice spoke.

"No! Jason!"

He didn't listen as the tears streamed his face. Arms grabbed him from behind. She hugged him from behind. Begging him to stay with her. His eyes were glued to the water below. The sparkling blue. It whispered his name. And just like that, he was falling again, into an abyss of emptiness. The sharp, jagged rocks below, turned into teeth as they crunched his body to pieces, leaving nothing.

Jason gasped, and sat up, sweat streaming his forehead. The clock on Allie's side table said it was 3a.m. He wiped his forehead. Allie was under the covers beside him, dressed in shorts and a tank top. Even in just his boxers, it felt like a

hundred degrees. He rubbed his head. The pounding started. He got up and went to the bathroom attached to Allie's bathroom. He splashed cold water on his face. He knew he had to go home. He needed his medication to stop the headaches. He turned off the light and walked back to the bed. Allie's hair was a mess; her face was flawless, even without make-up. Ignoring the voice telling him to go home. He found himself climbing into bed next to Allie, and falling asleep.

Allie

I woke up to Jason's soft snores. His face was practically smashed into the pillow beside me. I smiled. He was so...Perfect. His smile, the way he walked into a room, how we fit perfectly together when he hugged me. I smoothed his dark hair with my hand, slowly His black eyes fluttered open and he smiled at me.

"Good morning gorgeous." I said kissing his forehead.

He smiled at me and stretched his muscles. Sighing he sat up.

"How did you sleep?" I asked, hoping I didn't toss and turn.

He replied with "I slept great, only a couple of nightmares, but that's normal."

I frowned. He was just so strong. He saw the look on my face and took my hand in his.

"How bout some breakfast?" He suggested.

Looking at the time I saw it was 10 a.m. Mom was at work by now, and Bryson wouldn't be home till four. I nodded in agreement, and got up to make some pancakes. He followed me into the kitchen, and I felt his eyes on me while I made pancakes. I mixed the batter together, and heated up the skillet. After I finished making the batter, I poured it onto the skillet. When I looked at Jason, His face was blank, and he was starring off into the distance. I waved my hand in front of his face. He still didn't look at me. I touched his face; he flinched and moved away from me.

Jason

He watched her make pancakes, the way her body moved at a graceful pace, it made him smile. Then his mind started to wonder.

"She doesn't love you." The voices screeched inside his skull.

Jason ignored them. He could feel the throbbing in his head begin to start. Is eyes blurred and he rubbed them, His mind sent him false images of the world; they told him that Allie was a lie. Jason couldn't move, he froze. She's not real? He thought. What if she doesn't love me? He heard her voice.

"Jason?" She said worried.

No! His mind screamed. She touched his face. Jason quickly reacted as if his dad had just hit him. He jumped off the bar stool his was sitting on and backed away from her. His heart was beating at a faster rate than normal. He could feel the sweat on his face. Allie looked at him.

"Jason? W-what's wrong?" She stuttered.

Jason wiped the sweat from his face and took her hand in his.

"For a moment, I didn't think your where real." He said.

She gave him a small smile.

"Well I'm as real as you."

He nodded then said, "I need to call my mom. I need my pills."

She nodded.

"Okay, I understand."

He kissed her cheek, and ran to call his mother. Passing different doors. When he found Allies' he walked in and found his pants on the ground. He found

his phone in one of the pockets and quickly dialed his mother's number. It rang three times before his mother's voice was in his ear.

"Jason Lukas Dagonal! You where supposed to call me to come get you! I asked you if you were staying the night, and you said you weren't going to stay the night!-"

He interrupted his mother's rant,

"Mom, I know. I'm sorry. I just need my pills okay?"

He heard his mother sigh as she said okay.

"Thanks mom. Love you."

She mumbled a 'love you too.' Jason told her the directions then hung up his phone, and pulled on his pants, and then he slid his shirt over his chest. When he had finished putting his shoes on he walked down stairs to see Allie smiling.

"I'm sorry." He said looking down.

Allie hugged him tight and said,

"Don't be sorry, it's not your fault you need medication."

She looked up and kissed his lips tenderly. He encircled her with his arms.

"Jason?" She said worried.

No! His mind screamed. She touched his face. Jason quickly reacted as if his dad had just hit him. He jumped off the bar stool his was sitting on and backed away from her. His heart was beating at a faster rate than normal. He could feel the sweat on his face. Allie looked at him.

"Jason? W-what's wrong?" She stuttered.

Jason wiped the sweat from his face and took her hand in his.

"For a moment, I didn't think your where real." He said.

She gave him a small smile.

"Well I'm as real as you."

He nodded then said, "I need to call my mom. I need my pills."

She nodded.

"Okay, I understand."

He kissed her cheek, and ran to call his mother. Passing different doors. When he found Allies' he walked in and found his pants on the ground. He found

his phone in one of the pockets and quickly dialed his mother's number. It rang three times before his mother's voice was in his ear.

"Jason Lukas Dagonal! You where supposed to call me to come get you! I asked you if you were staying the night, and you said you weren't going to stay the night!-"

He interrupted his mother's rant,

"Mom, I know. I'm sorry. I just need my pills okay?"

He heard his mother sigh as she said okay.

"Thanks mom. Love you."

She mumbled a 'love you too.' Jason told her the directions then hung up his phone, and pulled on his pants, and then he slid his shirt over his chest. When he had finished putting his shoes on he walked down stairs to see Allie smiling.

"I'm sorry." He said looking down.

Allie hugged him tight and said,

"Don't be sorry, it's not your fault you need medication."

She looked up and kissed his lips tenderly. He encircled her with his arms.

"I love you." She whispered.

Jason went to respond, but his lips wouldn't move.

"I love you too." He said, but only his mouth moved, no words came out.

"Lies!" The evil voice screeched in his head. Jason could feel himself being ripped from Allie. She cried out in pain, but Jason couldn't do anything. His body was flung at the wall. He cried out in pain as he watched Allie fade, more and more. Jason screamed, but she faded, until she was gone.

Jason's heart pumped, as he felt the tears streaming down his face. Another nightmare. He could feel his mind racing, but he couldn't wake up. A coldness splashed on his face, but he stayed in his dark world. Voices screamed at him. Jason felt his body spasm. He wanted to scream, to wake up. He wanted Allie, to hold her, kiss her soft lips, he wanted to cry.

Lillian Dagonal

Jason?! Wake up!" she screamed at her son. His body didn't respond. She started crying as she splashed cold water on him. Still nothing. Lillian reached over to Jason's night stand and picked up his phone, her hands shook as she dialed 911.

"Hello, 911 wha-"

"My son! He won't wake up! I've splashed cold water on him, and he's still unconscious."

Tears streamed her face as the operator told her they had an ambulance on the way. She hung up. Jason still lay not waking. She could see wetness on his face. He was crying. It took 15 minutes for the ambulance to get to her house. And there she was again, waiting for answers that weren't received, waiting for doctors that never arrived, and waiting. Tears streamed steadily down her bright cheeks until one of the nurses finally called her name.

"Mrs. Dagonal?"

She picked her head up from her hands and sniffled.

"Yes, that's me. How is my son?! What's going on? I haven't been told-" The nurse cut her off.

"Mrs. Dagonal, I'm so sorry, but it looks like your son, Well, he died in his sleep, meaning his heart stopped beating. His brain was working though, processing images. It was like he died in a dream, so to speak. I'm so very sorry."

Mrs. Dagonal sobbed into the nurse's shoulder.

"No!" She cried. "I saw him not 12 hours ago, he was, was fine!"

The nurse held Mrs. Dagonal by the shoulders, saying,

"Mrs. Dagonal, Your son had a spasm attack when he was asleep, and since he was so deep in his sleep, no one could have done anything about it. He wasn't in pain when he went. He seemed at peace. We tried everything to try and get his heart to beat again. But as I've said before, I'm so sorry for your loss. You can see him if you'd like."

She nodded to the nurse, and was shown to her son's room. He lay there, under the thin white sheet, not breathing, his body was still. Lillian walked over to him and put her hand on his chest. Nothing. No heartbeat, no warmth. Her tears fell onto the sheet. She moved it back from his face revealing his handsome features. She let out a quiet sob when she saw his mouth. He was smiling.

"Why Him"
-Alex Mahoney

He does nothing

Just stands and stares,

But not at me.

No, He'll never care.

He'll never know

What it's like,

To feel this way,

To have this strife.

He never talks, no never speaks.

He never says a word,

At least not to me.

It's so hard

To walk away.

I wish I could,

But I want you to stay.

I want your arms around me,

But I know,

That will never be.

So I'll keep my words,

Bite my tongue,

Because a boy like you,

Doesn't deserve this love.

"Pine Cone"
-Danielle McCorkle

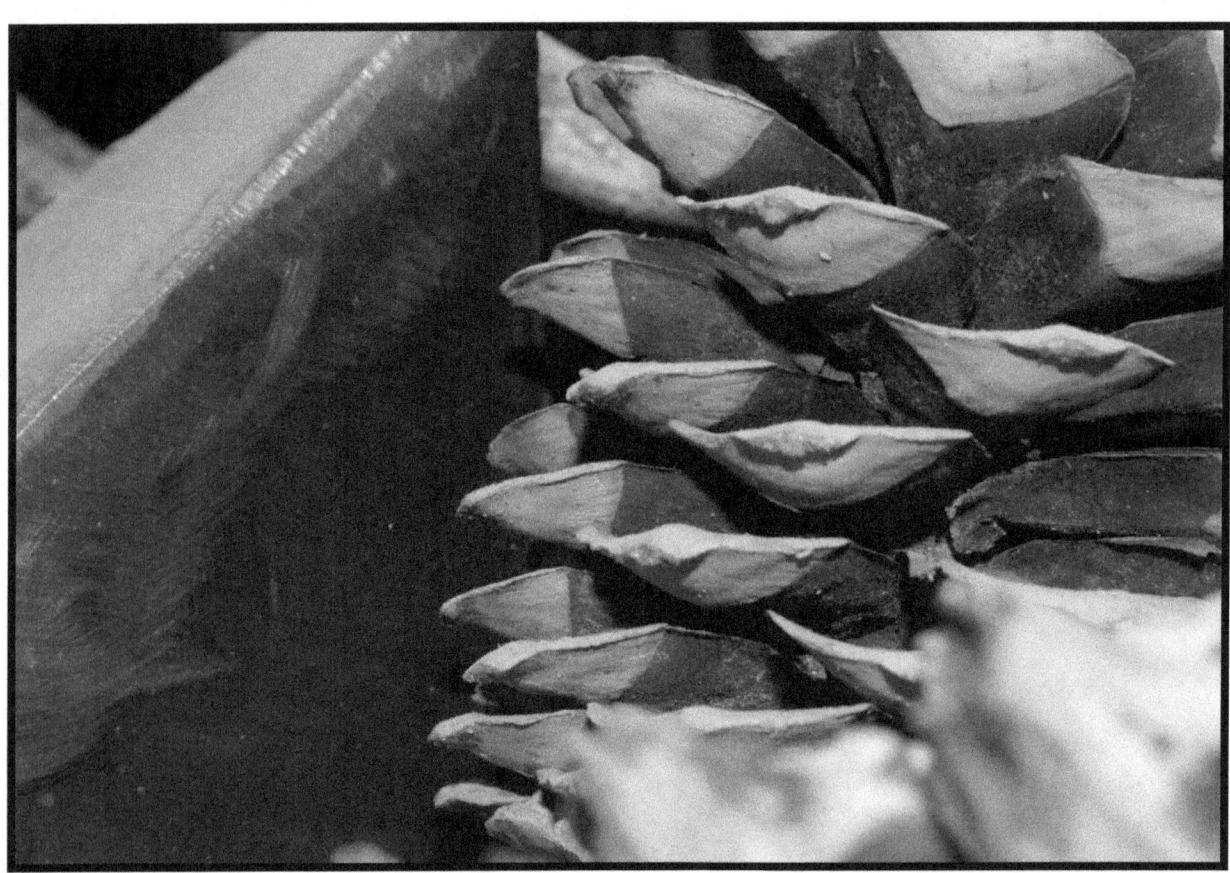

"You'll Understand"

-Siobhan Nickerson

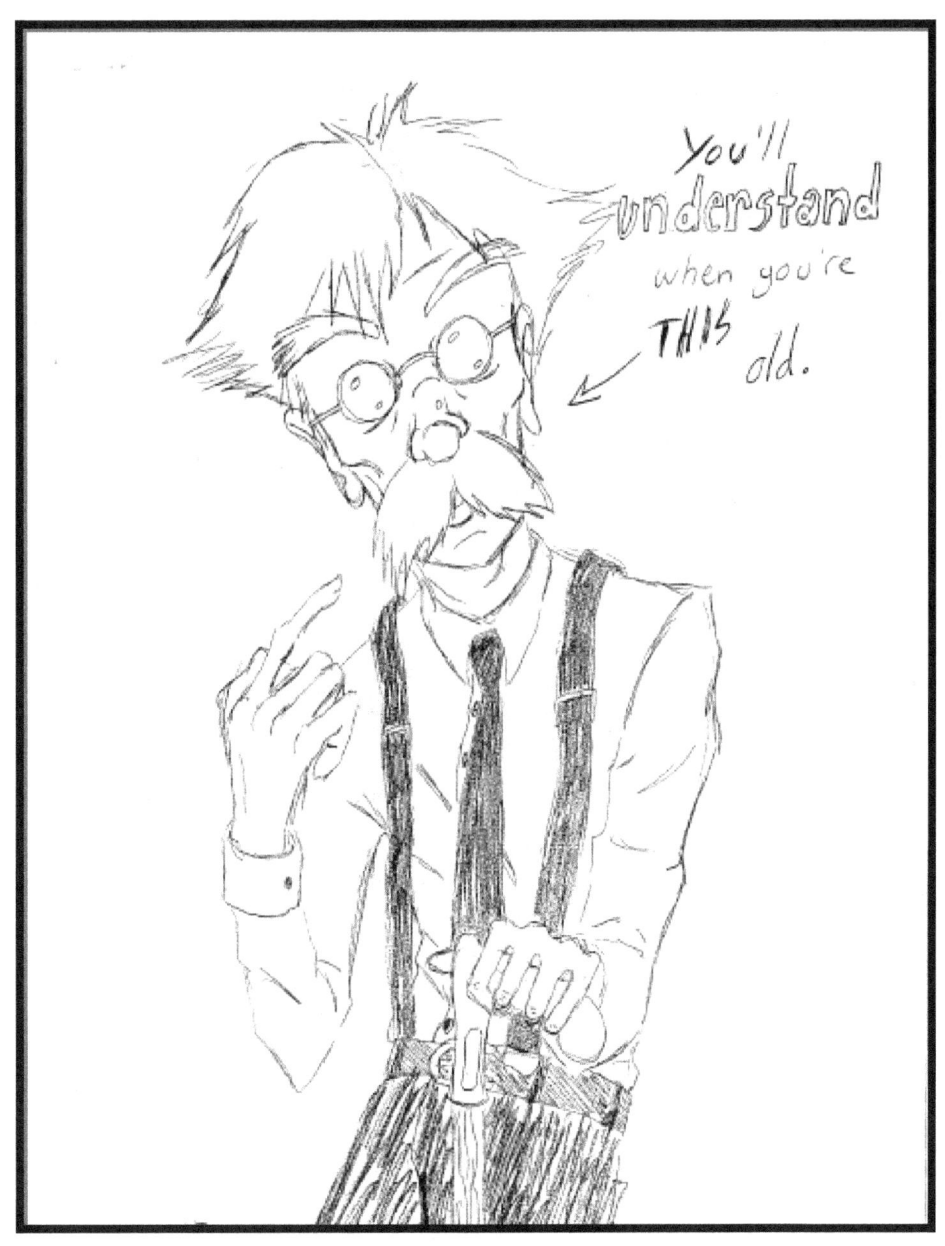

"Dream Shadows"
-Whilhelm Sitz

I.

The table had been laid lavishly with a delicate white table cloth, full of frills and intricate patterns, and the dishes that lay on top were the best set of china that the Michaels family owned; they were fragile and pale pink, the color of a sickly rose or the thin sunrise. Henry looked down at his plate, a golden pancake boat floating in an amber syrup sea. Two strips of bacon sat on the edge of the plate, watching the occurrence with vague interest.

Ellen emerged from the kitchen with Anne running about, a sock monkey cradled in her tiny arms.

"How's breakfast," Ellen asked, refilling Henry's coffee cup.

"Wonderful," he said, his voice a little shaky.

Ellen helped Anne into a chair, then sat next to Henry.

"What's the time, dear," Henry said as he dug into his pancake.

"There's a watch on your wrist, Henry."

There was. Henry looked down and saw he had a few minutes to finish his breakfast.

He chatted with Ellen, nervously, and then Anne, then he laced up his polished back shoes and put on his red tie.

And then he was leaving, and he walked outside and got into his blue sports car. A small shiver of nervousness passed through him. When he arrived at his office building, he would now be Henry Michaels, Chief Financial Officer. It sounded good. Henry smiled and stepped inside his car's leather interior. He started the engine and tuned the radio to a jazz station. Then he backed up slowly and drove out of the gated neighborhood with its high houses and landscaped lawns. He drove into the streets and merged into the traffic, weaving throughout the concrete buildings that rose from the earth, scraping the glaze of light blue like the fingers of God.

The city was beautiful. The streets were clean, free of debris and dirt. Tall oak trees lined the sidewalk, monolithic in nature, and the sun beat down and bled golden light. People walked the streets and they were happy; children ran and

licked ice cream cones and dropped them and then cried; and there was laughter, and it ruptured the sky.

And then something happened. The world vibrated. Pulsed. But in a second it had past.

He arrived at his office, and parked in a space marked EMPLOYEES ONLY. He walked inside and flashed his I.D. to the woman at the desk. She nodded, and Henry walked past her with a slight wave of his hand. He strode to the elevator and pushed the white button on the wall marked '12'. The doors closed slowly, and the elevator began to move up.

(pulse...)

Like water in a pond, the world turned into a rippling, unfocused mess, distorted and shimmering, and Henry was reminded of a carnival mirror. His eyes grew distant as he watched the sight in front of him, dizzying and unbalanced, as if his entire equilibrium was. Then it was gone again, as quick as it had come. But the angles of the elevator still seemed off. Distantly, he wondered if something was in his eye.

The doors (*pulse*) opened with a great clanging, and Henry stepped out onto the floor. He headed to his office, room number (*pulse*) 121. The doorknob felt cold in his hands. Henry himself felt rather disconcerted and (*pulse*) wobbly. His mind seemed out of focus, like he was wearing someone else's glasses. He stepped drunkenly to his office and finally made it into his black chair. He collapsed into it, and suddenly it was not his office but a dark room with a cupboard filled with bottles. The scene dissolved (*pulse*) and the office was back. Henry felt his wedding band heavy on his finger and looked over at the shelf where he kept a picture of his wife and Anne. They weren't there, but then they were, and then they (*pulse*) weren't again. The office spun around him and the papers on his desk flew upwards in a ferocious whirlwind. His mind strayed to Anne and something tugged at his heart. The wedding band was no longer on his finger. It was flying in the phantom wind. Henry jumped and (*pulse*) tried to catch it. But the (*pulse*) wind was too strong, and it flew mockingly around and around. He fell to the (*pulse*) ground and stared at the (*pulse*) sky and the wind and the papers, and that (*PULSE*) minuscule speck of gold. Something dropped on top of him as the world shimmered ferociously again.

And the office began to crack and rupture like glass, and pieces flew across the dark void that was behind it. And Henry Michaels flew with them, and in his

mind he realized that he was returning. He swept through the jagged pieces of the office, and there was a hard sadness that pierced his heart. He was almost there; he felt it. As he grew nearer, he came to realize that there was something still on his chest. He picked it up and stared at it. It was the picture of Anne, hos Anne, his daughter, smiling shyly, a gap where she had recently lost a tooth. As he flew through the whirlwind, he smiled.

He shivered once, twice. And then he woke up.

II.

He was lying on a bed, and he was cold. Every inch of his body was frozen and surging with intense pain. His eyes were open, and yet he could barely see. Gradually his vision focused, until he was staring at a glaringly white ceiling, a twisted fluorescent light shining down, trapped in its curved fixture. Henry felt weak and starving, which was strange, since he had only just eaten breakfast. And where was his office? Shouldn't his secretary be to his right, tapping away at her laptop? He looked over and saw a metal stand tangled with a multitude of wires and bags. Many of them lead to Henry himself. He touched his nose and found something there, and two IVs were attached to his wrist.

He looked down at his body. It was the color of a fish-belly, pallid and white. The sight was unfamiliar to him; he recalled that he was quite tan. He was also thin, so thin that he could count every bone in his body. And his fancy Armani suit was gone, replaced by a loose-fitting white shirt and large pants. Everything was bone white.

What had happened? He had been standing in his office, ready to work… and then the spinning, the fragments, the pulsing. Henry shook his head.

So it had all been a dream.

For a half hour, he cried.

III.

A nurse found him, but Henry wasn't sure what time it was. He called out to Ellen, asking if she knew, but Ellen was gone, locked away in some imaginary dreamland, and the nurse was calling in doctors and wheeling in machines, the phone was ringing and people were yelling excitedly, and it was all about him, because he had woken up and everything was painful and hard, and he sobbed as he looked for Anne, remembering he was getting her a Barbie Dreamhouse for

Christmas, but she wasn't real, there was no Anne, no Ellen, he was alone he was pale he was tired he was awake he felt sick.

And then it was quiet.

Then the doctor came over to him, speaking gently, and telling Henry he had been asleep three years. A car accident that had resulted in a coma. His wife was coming now, she was on her way and ecstatic that Henry had finally woke up. For a moment, Henry lit up, for Ellen was coming, and the doctor said no, it's Jamie, your wife, your Jamie.

Henry stared ahead blankly and leaned against his pillow.

IV.

She entered the room, escorted by the doctor. They were talking quietly, Jamie's face slowly losing its excited glimmer.

"Henry?" she said, watching him stare at her. She started to cry and walked over to his bed, and she grabbed Henry's hand and grasped it tight.

"You're awake, you're awake, everything's going to be okay now."

She cried and bent over and hugged Henry, but he couldn't remember her. Jamie couldn't be his wife. He would have remembered.

Jamie talked to him and cried for two hours, and then she got up and spoke to the doctor. Henry could hear them, discussing when Henry would be let out of the hospital. He was weak, the doctor said, and would continue requiring food intravenously until they could wean him off. There were medicines and pills to give him, and he'd need to be watched closely, at least for a month or two. Jamie wrote everything down.

And Henry watched. This was his wife. A few memories were filtering in; sunlight on the lake, a girl throwing flowers as Henry stood next to a lady dressed in white…and he saw a flash of Jamie's face beneath the lace veil.

Jamie was worried. Worried that he might slip back into a coma if he went back to sleep, but the doctor was saying things to reassure her, but Henry couldn't catch it. Then Jamie came over to him again, and she said that she was taking him home soon, and just sit tight until his release was all fleshed out. He nodded.

V.

He wasn't tired, but he did fall asleep that night. He had a dream, but it was shallow and silly, involving dancing polar bears and stand-up comedy, so unlike the deep, intricate piece of art he'd been living for five years. He almost wished he could slip back into it, see Annie and Ellen again, continue work as the new Chief Financial Officer. But it didn't happen.

He didn't know how many days it had been, but one day the nurse told him that the release forms had been signed, and he'd be going home that day.

Jamie came, and she wheeled Henry out in a wheelchair. He was stunned when he was brought outside. And then he was put in a large van with a ramp.

Jamie drove Henry, and she was always smiling. This was his wife.

Henry looked outside the window.

"Why…why is everything so dirty?" he asked. His voice was thin and wobbly.

"Oh, it's the city life. Cars and pollutants and trash everywhere," Jamie said, happily. "It's not so bad."

But it was. The streets in his city, in his dream, they had been so clean. Jamie talked for the rest of the car ride home.

She cried and bent over and hugged Henry, but he couldn't remember her. Jamie couldn't be his wife. He would have remembered.

Jamie talked to him and cried for two hours, and then she got up and spoke to the doctor. Henry could hear them, discussing when Henry would be let out of the hospital. He was weak, the doctor said, and would continue requiring food intravenously until they could wean him off. There were medicines and pills to give him, and he'd need to be watched closely, at least for a month or two. Jamie wrote everything down.

And Henry watched. This was his wife. A few memories were filtering in; sunlight on the lake, a girl throwing flowers as Henry stood next to a lady dressed in white…and he saw a flash of Jamie's face beneath the lace veil.

Jamie was worried. Worried that he might slip back into a coma if he went back to sleep, but the doctor was saying things to reassure her, but Henry couldn't catch it. Then Jamie came over to him again, and she said that she was taking him home soon, and just sit tight until his release was all fleshed out. He nodded.

V.

He wasn't tired, but he did fall asleep that night. He had a dream, but it was shallow and silly, involving dancing polar bears and stand-up comedy, so unlike the deep, intricate piece of art he'd been living for five years. He almost wished he could slip back into it, see Annie and Ellen again, continue work as the new Chief Financial Officer. But it didn't happen.

He didn't know how many days it had been, but one day the nurse told him that the release forms had been signed, and he'd be going home that day.

Jamie came, and she wheeled Henry out in a wheelchair. He was stunned when he was brought outside. And then he was put in a large van with a ramp.

Jamie drove Henry, and she was always smiling. This was his wife.

Henry looked outside the window.

"Why…why is everything so dirty?" he asked. His voice was thin and wobbly.

"Oh, it's the city life. Cars and pollutants and trash everywhere," Jamie said, happily. "It's not so bad."

But it was. The streets in his city, in his dream, they had been so clean. Jamie talked for the rest of the car ride home.

Henry had solid food for the first time in three years that night. He gorged himself and vomited afterwards, retching and coughing it all up. He could walk easier now, but his body was still sore and weak. Like she had been at the hospital, Jamie was afraid of what would happen when Henry went to sleep. Still, he couldn't stay up forever, but Henry noticed she tossed and turned with worry all night.

Sometimes when he slept he experienced glimpses of his past dream. There would be a flash of Ellen's face, or maybe Anne's, and they were both so happy. He saw fragments of his job, and his car, of the beautiful city. And then he would wake up next to Jamie, only a shade compared to Ellen, to his dream.

But all the memories were coming back now. He could recall almost all of his life, and began to cry more often because of it. He remembered their wedding, their honeymoon, Jamie's miscarriage.

He remembered that it was a girl, and they were going to name it Anne.

Every waking hour was pain. He was growing stronger, but nothing brought him joy. Jamie took him to a play one night, a musical about a prisoner who became a mayor and went to some barricades, but it did nothing. There was only pain here. Everything was dirty.

Sometimes, when he was alone, he thought about Anne and Ellen, and wondered why he had ever married someone like Jamie. She was always next to him, talking and chatting about how grand everything was now. But it wasn't, and Henry knew it. Here people died. They drank away their sorrows and puked them back up on the streets. They cried and killed because they knew nothing better.

But the food was good.

And then he'd remember Ellen's cooking, and it was times like those that he thought of things.

They were strange, and often alarming. But as the days ticked by, the more Henry found his mind dwelled on them.

And one day it came to him, and he knew he was right. He could even feel it at times, like a phantom piece of himself moving, but not where Henry stood. Elsewhere.

He came to the conclusion that some part of him was still there. With Anne. With Ellen. Moving about and going to work. And it was looking for him.

Henry slept that night, willing himself to return to that dream, that wonderful, clean dream. He found it one night. He was watching himself talk with

Ellen and Anne, in the kitchen, and all three of them were happy. He reached out, extending his hands in hopes of diving deep into that dream once more, but then he woke with Jamie next to him.

He began to go to bed earlier, try to sleep whenever he could. All he needed was time, but there never seemed to be enough.

The days became bleaker, and Jamie's optimistic attitude was growing thin, stretched by the depression that hung over Henry like a noose. Henry noticed it, and he felt a disturbing sense of satisfaction; maybe now she'd know how it felt to have something, only for it to be thrown away.

But she was always around him, still, and sometimes she cried in front of him. Henry looked away and remembered Ellen and Anne.

Then it happened one night. Henry dreamed hard, and he fell back inside his old dream, if only briefly.

Anne was standing in her footie pajamas, holding her sock monkey. She was crying.

"Mommy," she whispered, her voice tremulous. "Where's daddy? Isn't he coming back?"

Ellen was not there and then was. She turned, and was facing Henry.

Her image flashed, and she was nothing but bones and sagging flesh.

"He's there," Ellen said, normal again. "He's there but he won't come back in."

The dream shattered, and Henry woke up. They needed him.

He got up out of bed, careful not to wake Jamie, and walked down the stairs into the kitchen. There was a small flashlight on the table, and he picked it up.

Above the stove was Ellen's medicine cabinet, filled with all her prescriptions and medications. Somewhere in the assortment she must have something to help one sleep.

He opened it up and rifled through the miniature bottle. He found a good assortment of vitamins, and then some antidepressants. Finally, in the back depths of the cupboard, sleeping pills. The bottle was half-empty. He pulled it out and closed the cupboard quietly.

From upstairs, Henry heard a sound. There was a creak of bedsprings, and then the sound of footsteps. It was Jamie, obviously having noticed his absence.

Henry froze for a moment, then turned to the bathroom. He could hear Jamie coming closer, taking deliberate yet quick steps to his location. Henry grasped the sleeping pills tightly and fumbled with the lid. It was screwed on tightly, and barely budged.

"Henry?" Jamie said. She was suddenly there, in front of the bathroom doorway, her eyes lined with deep worry. Henry shut the door with a clang and fumbled with the antique lock. Jamie's fists banged on the other side of the door, and before he could lock it, the wooden frame moved inward.

Jamie was staring at Henry, and then saw the pills in his hand.

"Don't do that," she said, her eyes filling with horror.

It was funny, really. Henry watched Jamie with subdued enthusiasm. She thought he was going to kill himself? Ridiculous.

He finally managed to unscrew the cap, and Henry raised the bottle to his mouth. But Jamie was there, screaming and running forward, and she knocked the pill bottle from his hand. Henry cried out and fell to his knees, his eyes searching for the pills in the dark.

"Henry!" she screamed, and she was crying. "Henry!"

He found the pills and stood up. Henry looked at Jamie. She would only stop him again. He grabbed onto her shoulders and pushed her back.

Jamie fell to the floor without a cry. He looked at her for a moment, now drifting in a dream world herself. She looked more peaceful now, as she lay unconscious on the floor.

Henry sat down in a comfortable place, placing a towel over himself, and then dropped six pills into his mouth. He swallowed them dry, then closed his eyes.

He drifted, followed the stream as it propelled him forward. Then he was there. He was in the dining room and the light was on. He smiled and watched. Overhead the light flickered like a luminous lightning bug, and a splatter of vivid yellow circles obstructed his vision. He reached out and pushed the light away, and then the light went out.

He walked toward the kitchen. He felt a flash of black, but he continued forward. In the doorway to the kitchen, Henry saw shadows. They danced against the wall, their arms and legs grotesquely disfigured, but they smiled and were happy. They danced wildly and without apprehension, the figures in a puppet show, pulled by invisible strings that went on infinitely until they stopped. He wanted to touch the shadows.

"Annie? Ellen?"

The lilting sound of jazz wafted to his ears, and he walked into the kitchen, and he danced with the shadows.

"Him"
-Avery Thomas

Soaking wet

Dry like a desert

Heavy as steel

Light as a feather

Fine as a fingerprint

Rough as sand

Frightening as the creature under your bed

But, welcoming as Gabriel's sweet melody

You know it as silence

As a whisper in the wind

The chills down your back

The breath on your neck

It can be loud as thunder

A trumpeting call

It will lure you in

No matter if you run

Or embrace its own

Dark

Cloaked

Shadowy

Arms

It is

Death

"They Loved"
-Avery Thomas

Lost a loved one recently?

I have, her name was

Life

She was taken by someone known to me

In fact, you know him too

Tall, strong, and angry

So angry that you hide from him

So angry that the world plays keep-away with his dreams

Dreams of darkness

Dreams that you will find him

He hates happiness, but longs for love...for care

She was taken, hated for her brightness, but,

Wanted for love.

She was stolen -Life was stolen

Loved -She brought happiness

Life was sometimes sad

Longed for him

But when she finally got him

He destroyed her

Broke the world around her

Flood gates open, Rain storms

Dark clouds, Thunder, Lightning

Showed Life's passion for darkness

But also for light

While she was destroyed

He searched for another

Humanity wants him, but does not want the pain

Like every relationship, there is always a fight

Was it love, or was it lust?

Is it anything-

Or am I just rambling?

I ask questions in search of an answer.

Within my mind an answer already decided

I loved Life -with all my heart, every last broken piece

Not knowing what happened -no one ever does-

But in my head, had a decision

I knew I had one -just hadn't acted

He was destruction, but in that, there is always a light

A tunnel meant for passage,

And the end, there is no knowledge

There is no innocence,

There is just, light

A light before darkness.

Or just open light,

Everyone.

Everyone finds him.

Everyone is taken.

Whether you were searching for him

Or just content with who you have

Those people are somewhat rare.

You are very lucky if he finds you first.

For if you find him, before he finds you.

Chasing after someone who is not ready for you

Someone who wants you but is extremely hesitant

She was believed to be ready.